IMAGES
of America

SAN FRANCISCO'S
MISSION DISTRICT

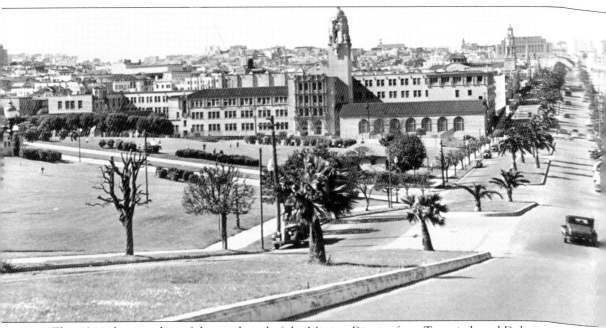

This 1944 photograph is of the north end of the Mission District from Twentieth and Dolores. Dolores Park and Mission High School look much the same. The biggest differences are in the size of the palm trees and the number of automobiles. (Courtesy of San Francisco Public Library, AAA-6828.)

ON THE COVER: The League of American Wheelman pose at Twenty-first and Capp Streets on the day of their "Century Run" in 1890.

IMAGES
of America

SAN FRANCISCO'S
MISSION DISTRICT

Bernadette C. Hooper

ARCADIA
PUBLISHING

Published by Arcadia Publishing
Charleston SC, Chicago IL, Portsmouth NH, San Francisco CA

Printed in the United States of America

Library of Congress Catalog Card Number: 2006924389

For all general information contact Arcadia Publishing at:
Telephone 843-853-2070
Fax 843-853-0044
E-mail sales@arcadiapublishing.com
For customer service and orders:
Toll-Free 1-888-313-2665

Visit us on the Internet at www.arcadiapublishing.com

For the teachers of the Mission District

CONTENTS

ACKNOWLEDGMENTS

The best part about this project has been meeting more people with a deep appreciation of the Mission District. I wish they could all meet each other.

I want to thank the following for kindly sharing time, memories, and photographs: Ralph and Lupe Abeyta, Don Alan, Molly Arthur, Dorothy Baciocco, John Barbey, Mary Evelyn Bisazza, T. J. Buckley, Dr. Jeffrey M. Burns, Patricia Cavagnaro, Florence Cepeda, Chris Collins, Marie Driscoll, Frank Dunnigan, Joe Evans, Jules Fraden, Anne Fuchslin, Katherine Bellis Hamburger, Karen Hanning, Tom Harvey, Andrew Galvan, Roberto Gonzalez, John Hider, Martin Jacobs, Julie Lyons, Annely Kelleher, Teddy Gray King, Freda Koblick, Dennis McEnnerney, Virginia Mehegan, Christine Miller, Anson Moon, Nils Nielsen, Helen O'Brien, Kathleen Regan, Kate Rosen, the Ruane and Loftus families, Linda Moller Ruge, Paul C. Ryan, Etienne Schier Simon, Ralph Simon, Dr. Ted Scourkes, Walter Swan, Mickey Sweeney, Marian Tandy, Edna Vierucci, Richard Weinand, Linda Westerhouse, and Sr. Janice T. Wellington, O.P.

For the privilege of viewing their collections, I thank the patient staffs of the Archives for the Archdiocese of San Francisco, the California Historical Society, Carnaval San Francisco, Mechanic's Institute Library, the San Francisco History Room of the San Francisco Public Library, Mission High Alumni Room, St. Anthony-Immaculate Conception School, Immaculate Conception Academy, St. James School, San Francisco General Hospital, and the San Francisco General Hospital Foundation.

Special thanks to Tricia O'Brien, Frank Dunnigan, and Lorri Ungaretti for their ideas, time, and laughter, and to John Poultney for his patience and focus. Finally, thank you to my mother and family members for their love of the neighborhood that was home to us for four generations.

INTRODUCTION

San Francisco's Mission District looks at over 200 years of local history, starting from the days when it was chosen as the site for La Mision San Francisco de Asis to recent days. Residents and other locals refer to the area simply as "the Mission."

The Mission District is located in a sheltered valley surrounded by Twin Peaks, Mint Hill, Potrero Hill, and Bernal Heights. Approximately one mile square, the district is bordered by Market and Division Streets on the north, Church or Dolores Street on the west, the north side of Bernal Heights to the south, and Highway 101 to the east. From the first, this valley was blessed with good weather, an abundance of water, and at least one navigable creek with an outlet to the bay. There was also a lagoon, waterfowl, and other game. The people who hunted, gathered, fished, and took shelter in the valley were the Ohlone. This was the village that they called Chutchuii.

In 1774, Col. Juan Batista de Anza explored the San Francisco region. It was his duty to determine the best location for a presidio and a mission. If successful in its goal to convert natives, the mission would grow into a pueblo. Locating the presidio at the entrance to the Golden Gate was a strategic necessity. The mission was another matter. It had to be self-sustaining and could be located somewhere warmer and more favorable to farming and grazing. In a valley three miles southeast of the presidio, they found what they needed: firewood, water, tillable soil, and pasture.

In June 1776, Lt. Jose Joaquin Moraga led a band of soldiers and two Franciscan friars, Francisco Palou and Pedro Cambon, to the valley chosen for their mission. On June 29, 1776, Father Palou said Mass on the shores of the Laguna de los Dolores and the mission was begun. It was named in honor of St. Francis of Assisi, the founder of the Franciscan Order. In time, the mission became popularly known as Mission Dolores.

By 1791, the permanent mission church known today was constructed. Eventually the mission property included 20 buildings. The new converts were required to live in or near the mission. They labored to make the community self-sufficient. This was typical of the mission system. Although many natives willingly remained with their new faith, their way of life was gone forever. In the years that followed, the population of the mission grew, orchards were planted, cattle were pastured, and crops were planted with varying degrees of success. Along with infrequent supply ships from Mexico, an occasional foreign ship put into port. According to journals, officers of non-Spanish ships traveled to the mission and were warmly greeted. For some, the sight of the little outpost of the Spanish empire had charm, but many commented on the conditions of the Ohlone. Otto von Kotzebue and Georg von Langsdorff before him noted the decreasing numbers of Ohlone due to disease.

In 1821, Mexico gained its independence from Spain. The new government in Mexico City had little time or resources to support the California missions. The final straw came in 1834 when the Mexican government secularized mission lands. No longer did the Franciscans control vast areas that stretched from mission to mission along the El Camino Real. Mission Dolores was reduced to the status of parish church. What followed was settlement by minor officials, professionals,

and people of various trades. Francisco de Guerrero, an attorney from Tepic, arrived in 1834. By 1836, he was living at the mission with his family. He served as alcalde, a combination justice of the peace and mayor, and was given a land grant. Streets in the neighborhood were named for Guerrero and Candelario Valencia, another early settler. The settlement that was established at the harbor in 1835 was called Yerba Buena. The area around Mission Dolores was then called the Dolores Pueblo.

Yerba Buena was renamed San Francisco in 1847. With the signing of the Treaty of Guadalupe Hidalgo in 1848, California became part of the United States. After the gold rush, the mission valley was "discovered" again. It became a rural home for some, farm land and playground for others. In 1849, Bayard Taylor observed changes in the mission valley where "former miners" had taken up gardening near Mission Creek. He also noted that the valley had been surveyed and lots staked "almost to the summit of the mountains." Two racetracks, the Union Track and the Pioneer, were located in the area, south and east of Mission Dolores. The Willows, a resort near the Dolores Lagoon, and Woodward's Gardens became popular destinations. Dirt roads existed, but plank roads on Mission Street and Folsom Street made the going easier, particularly over sand dunes. At Army Street (then New Market), a wooden toll bridge spanned the Serpentine Creek. Numbered streets such as Twenty-fourth and Twenty-fifth were then called Park and Yolo, and Dolores Street was called El Camino Real.

Working-class people and wealthy citizens built their homes in the Mission District. John and Claus Spreckles, owners of C&H Sugar, had mansions on South Van Ness (then Howard). One Mission District home listed in the San Francisco real estate circular of 1880 featured a windmill. A home on Liberty Street with 10 rooms was advertised for $10,000. The neighborhood that once housed Ohlone, then Spanish and Mexican settlers, was now home to people from many nations, mostly Europeans. The neighbors had many occupations; a large portion of them were laborers or in skilled trades. Organized labor had a champion in the Mission District, Fr. Peter Yorke, pastor of St. Peter's Church.

The earthquake and fire of 1906 destroyed part of the neighborhood, as far south as Twentieth Street. With the rebuilding of the city came an increase in light industry in the northeast part of the neighborhood. Breweries, bakeries, and dairies were big employers. The Mission District had easy access to jobs downtown and on the waterfront.

Young families in the 1920s looked to booming times, but they were short-lived. With the Depression, neighborhood merchants, especially those that sold on credit, lost businesses after customers lost their jobs. Life continued with simple pleasures. Neighborhood movie houses were a big draw on Saturdays. At the El Capitan on Mission Street, there was an orchestra and one could spend the afternoon seeing a "chapter" (part of a serial), a vaudeville act, and a feature film—all for 10¢.

The Mission mobilized for World War II. In addition to entering the service, neighbors went to work to help the war effort, stood in line for rationed goods, made do, or went without. Newcomers from out of town or out of state came to the neighborhood to work at nearby shipyards.

The postwar years saw many changes to the neighborhood. The wartime housing shortage continued as many young people began to marry. Many made the move to new homes in the suburbs or "west of Twin Peaks." New groups, including greater numbers from Central America, settled in the Mission. In the 1960s, it was back to wooden sidewalks on Mission Street while BART construction played havoc with shopping patterns. Some businesses did not survive the transition. Hale's store made way for Value Giant. New merchants moved in, responding to the needs of newer residents.

By the 1980s, another wave of change was beginning—younger people fresh to the Mission or to San Francisco discovered the good weather, reasonable rents (if you lived with several friends), and the open-minded spirit of the neighborhood. Their sensibilities mixed with what was already there and increased the demand for new theatres, movie houses, restaurants, bookstores, and nightlife. New local celebrations grew out of the mix of residents from many Latin countries and those who appreciated their traditions. Carnaval, Cinco de Mayo, and Dia de los Muertos began

in the Mission as small neighborhood events open to the whole community. The settlement where the city began is still the place for new traditions.

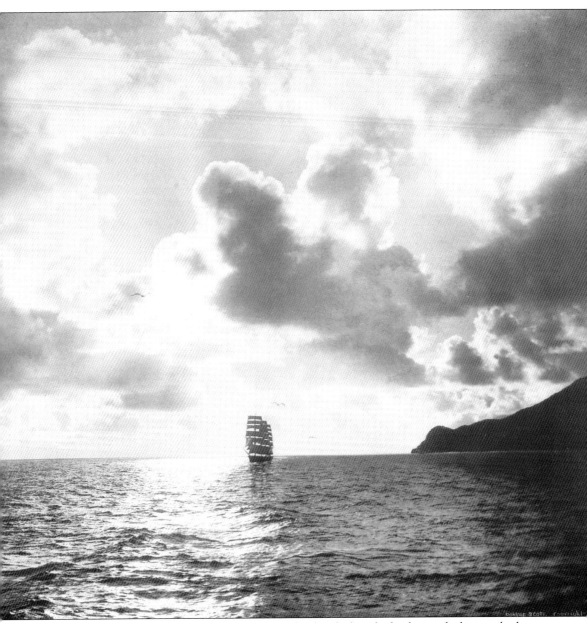

A sailing ship is pictured at the Golden Gate in the days before the bridge, with the area looking much like it did to the early European explorers. In 1826, British naval officer Frederick Beechey visited the great harbor and was given "excellent hospitality" at the small settlements at the Presidio and Mission Dolores. Beechey was impressed with the great harbor and the natural setting but observed with "regret that so fine a country, abounding in all that is essential to man, should be allowed to remain in such a state of neglect." This was not a condition that lasted for long. (Courtesy of Paul C. Ryan.)

One

MISSION TO
NEIGHBORHOOD

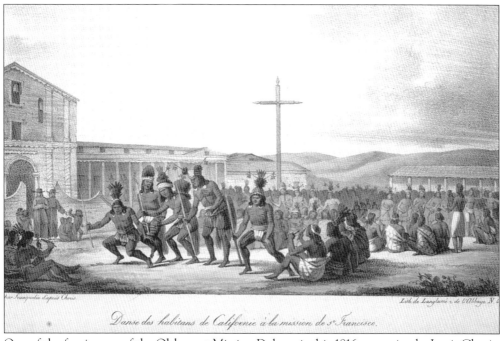

Danse des habitans de Californie à la mission de s. Francisco.

One of the few images of the Ohlone at Mission Dolores is this 1816 engraving by Louis Choris. At the beginning of the settlement, the Ohlone lived in structures of traditional design—conical shaped, constructed of willow, and six to seven feet in diameter with a hole at the top to let out smoke. Many were eventually housed in adobe structures at the mission. (Courtesy of Archives for the Archdiocese of San Francisco.)

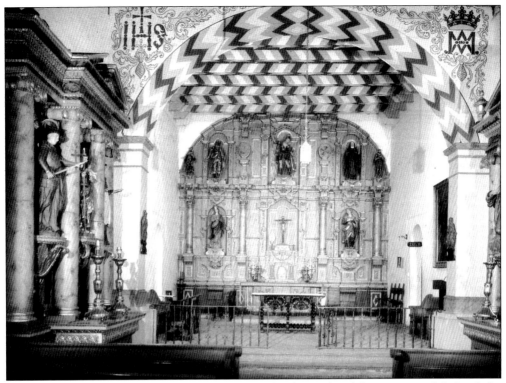

The interior of Mission Dolores remains a peaceful refuge. The elaborate artwork behind the altar, a *reredos* from Mexico, was installed in 1796. Behind that is earlier artwork by the Ohlone. In 2004, archaeologists were able to project digital images of the Ohlone paintings onto the ceiling of the Basilica next door. Andrew Galvan, the current curator of Mission Dolores, is Ohlone and the descendant of a native baptized at Mission Dolores. (Courtesy of Archives for the Archdiocese of San Francisco.)

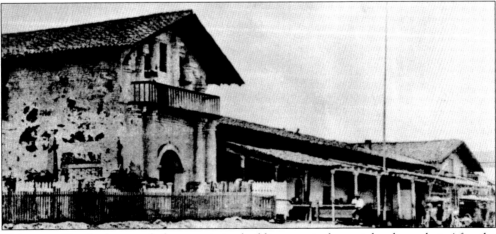

This post-gold rush photograph shows a mission building seemingly overtaken by neglect. After the secularization of mission lands in 1834, it was reduced to the status of a parish church. The lands upon which the Ohlone had toiled were granted to government officials and ambitious settlers. Few of the settlers were able to prove or keep title when California became a state. (Courtesy of Archives for the Archdiocese of San Francisco.)

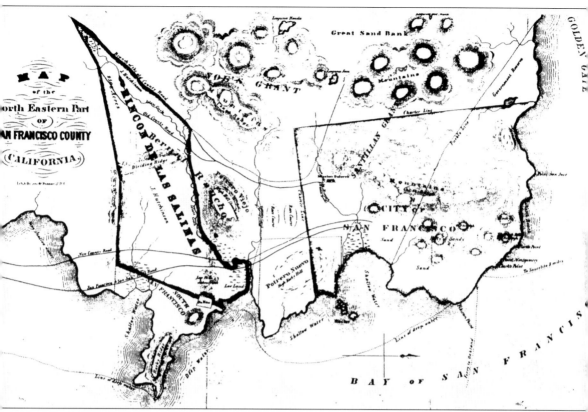

This Rincon de las Salinas map of the northeastern part of San Francisco County shows that Mission Dolores lies within the city charter line. The circular areas were racetracks outside the charter line. Surrounded on three sides by the remnants of land grants, the Mission District was a rural spot on the edge of the new city.

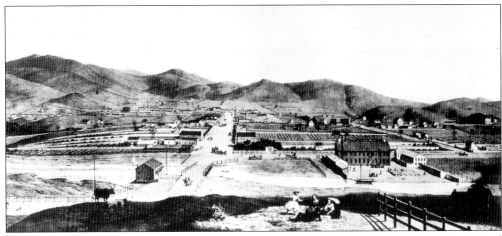

From the time of the early settlers, the Mission area was a place for farming, cattle raising, and sport. Mission Dolores appears in the distance of this panoramic drawing, below Twin Peaks. In the foreground is Mission Creek. In 1924, a local journalist recalled a time 50 years before when Mission Creek ran up to Sixteenth Street and Harrison and "folks used to swim in it . . . as far as the sugar refinery at 8th and Brannan." The creeks of the area are still "alive," a presence in basements after spring rains. (Courtesy of Paul C. Ryan.)

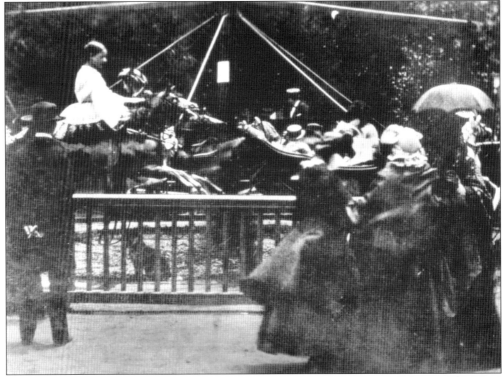

A ride at The Willows, an early resort in the Mission, is seen in this 1864 photograph. It was located between Valencia, Mission, Eighteenth, and Nineteenth Streets on the site of the Laguna de Los Dolores, a natural spot for native willows. The area was also called "The Weepers," for the willows and for some Ohlone who had cried at their first sight of Spanish soldiers. (Courtesy of California Historical Society, FN-30537.)

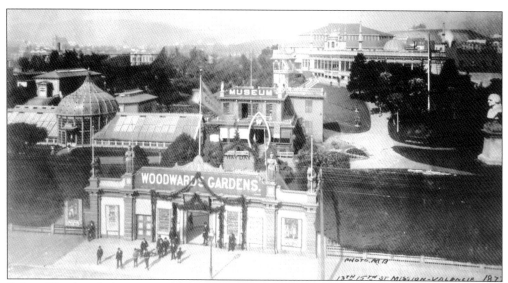

Robert Woodward, the owner of the What Cheer Hotel, had an estate at Fourteenth and Mission Streets that included gardens, a hothouse, and a gallery filled with copies of European master paintings. Living on a grand scale made him conspicuous, and so many of the curious came to see his home from the distance of his gates, that he was persuaded to open the grounds to the public. Woodward's Gardens was a poplar destination from 1866 until 1894. (Courtesy of California Historical Society, FN-19425.)

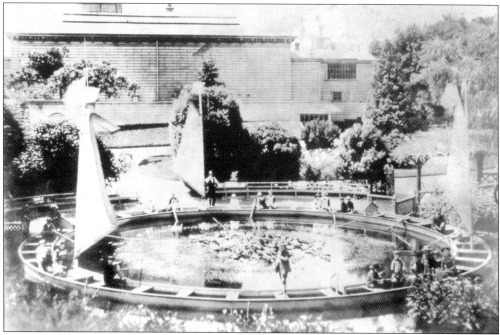

Sailing in the circular boat was one of the many ways San Franciscans found to relax at Woodward's Gardens. Woodward added more attractions, including a zoo, an aquarium, and a theatre. His resort is remembered with an historical marker at Mission and Division Streets, a half-block alley named Woodward, and a restaurant named Woodward's Gardens. (Courtesy of California Historical Society, FN-00353.)

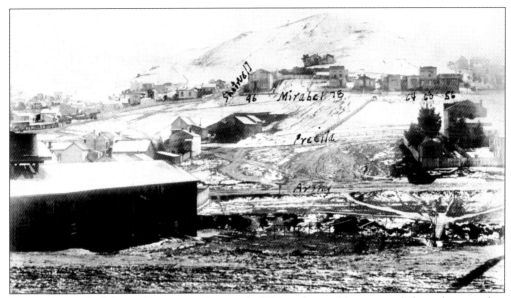

Snow came to the Mission District on January 1, 1883, and stayed long enough for a photographer to take this picture of the north slope of Bernal Heights. Fortunately the street names and house numbers were noted, or this could be mistaken for a western mountain town of that era. (Courtesy of St. Anthony-Immaculate Conception School.)

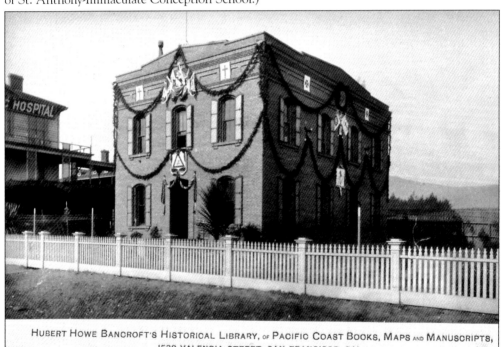

HUBERT HOWE BANCROFT'S HISTORICAL LIBRARY, of PACIFIC COAST BOOKS, MAPS and MANUSCRIPTS, 1538 VALENCIA STREET, SAN FRANCISCO, CAL.

Hubert Howe Bancroft moved to San Francisco in 1852 to open a bookstore. Bancroft became fascinated with the West and spent decades researching, writing, and publishing its history. He maintained his library at 1538 Valencia Street, near Army Street. In 1905, Bancroft sold his collection to the University of California, Berkeley. (Courtesy of California Historical Society, FN-25501.)

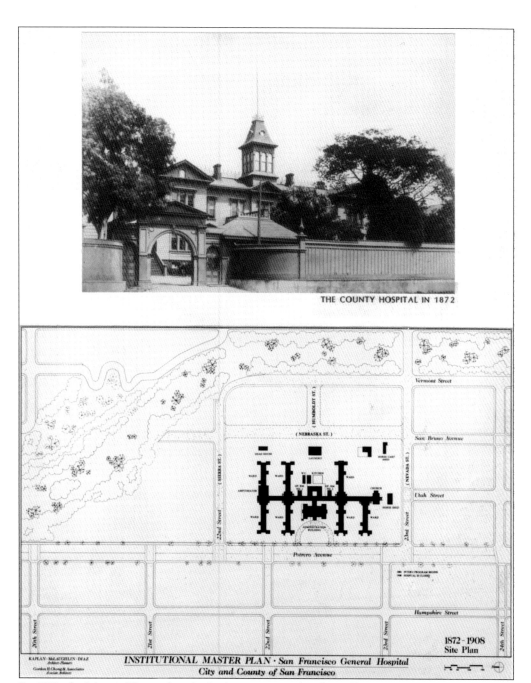

THE COUNTY HOSPITAL IN 1872

Vermont Street

(HUMBOLDT ST.)

(NEBRASKA ST.)

San Bruno Avenue

(SIERRA ST.)

DEAD HOUSE LAUNDRY

HORSE CART SHED

(NEVADA ST.)

Utah Street

WARD WARD W.C. KITCHEN WARD

AMPITHEATER OP. RM BP. RM No. 1 CHURCH

WARD WARD WARD WARD HORSE SHED

ADMINISTRATION BUILDING

22nd Street

23rd Street

Potrero Avenue

INTERN PROGRAM BEGINS
HOSPITAL IS CLOSED

Hampshire Street

20th Street

21st Street

22nd Street

23rd Street

24th Street

1872 - 1908
Site Plan

KAPLAN - McLAUGHLIN - DIAZ
Architect Planners
Gordon H. Chong & Associates
Associate Architect

INSTITUTIONAL MASTER PLAN · San Francisco General Hospital
City and County of San Francisco

By 1870, the Marine Hospital at the harbor was considered insufficient for the needs of the city. A county hospital was planned on Potrero Avenue, a remote location. The staff and patients managed despite poorly constructed buildings. The map of the grounds includes a "dead house." Some strange economies were practiced. The hospital once paid a $2,000 invoice for wine. It was not used for staff parties but dispensed to patients instead of costly medicine. That practice was not long-lived. Fortunately the hospital was able to secure dedicated staff and has benefited from long affiliations with local medical schools, including the University of California, San Francisco. (Courtesy of San Francisco General Hospital.)

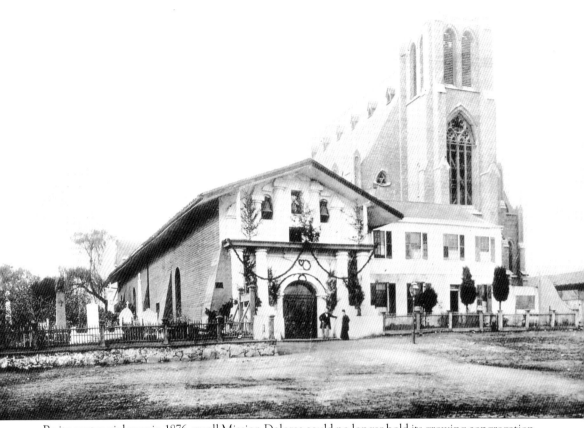

By its centennial year in 1876, small Mission Dolores could no longer hold its growing congregation. A larger parish church was constructed next door. The new church was so heavily damaged by the 1906 earthquake that it had to be torn down. However, Mission Dolores, with its thick adobe walls, survived beautifully. The mission church has undergone at least two restorations, the first directed by Willis Polk in 1917. During recent restoration, the contractor was able to incorporate adobe dust from the original building into the new materials. (Courtesy of Archives for the Archdiocese of San Francisco.)

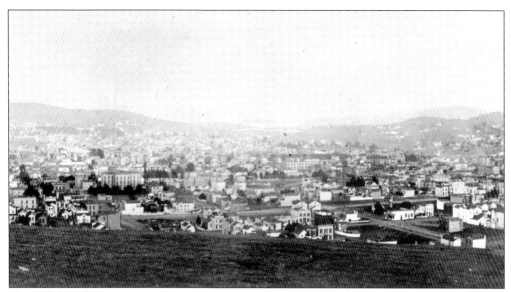

This 1884 southeast panoramic view shows Army Street and possibly remnants of the Serpentine Creek on its course to the bay. Potrero Hill is to the left, and Bernal Heights is to the right. The neighborhood was filling up with homes and businesses. (Courtesy of Paul C. Ryan.)

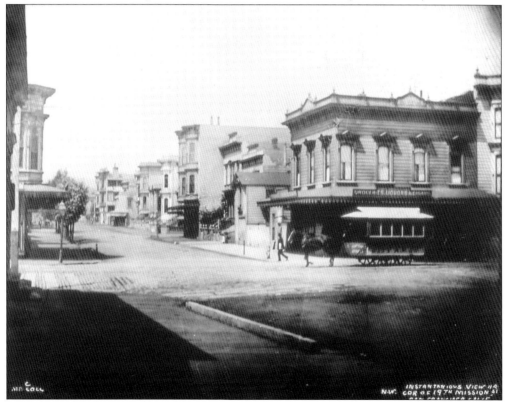

The corner of Nineteenth Street and Mission Street was already bustling by 1880. Wooden sidewalks were the norm, and the neighborhood had omnibus service. (Courtesy of California Historical Society, FN-30768.)

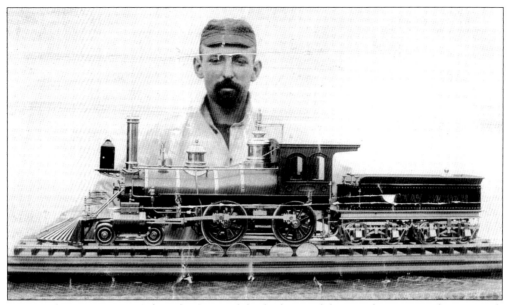

German-born Gustav P. Schier (1869–1916) built this model steam locomotive from scratch over an eight-year period. The engine was exhibited at the Midwinter Exposition in 1894 and at an industrial fair at the Mechanics Institute in 1897. For many years, it held center stage in the main parlor of Schier's home on Vermont Street. It has been on special display at the California Railroad Museum in Sacramento since 1982. (Courtesy of Schier family.)

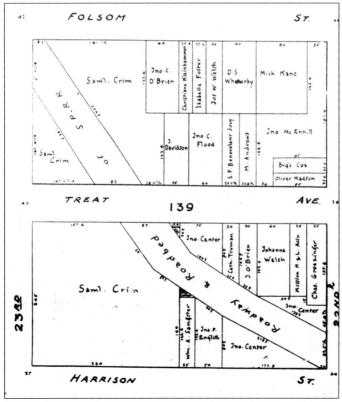

In 1863, the San Francisco-San Jose railroad established its line south and west through the Mission District, with a stop at Twenty-fifth and Valencia Streets. This 1901 block map of Twenty-second and Harrison Streets shows the many odd-shaped lots along the right-of-ways.

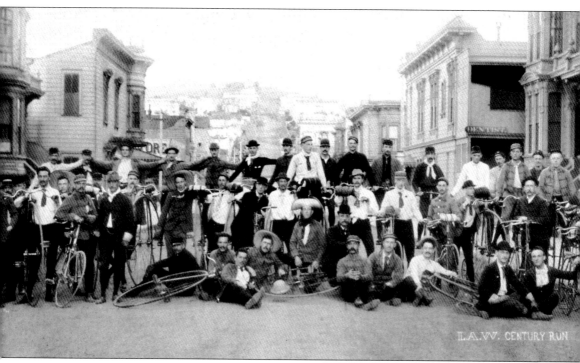

The League of American Wheelmen posed at Twenty-first and Capp Streets in 1890 on the day of their "Century Run." The transition from high-wheel bicycles was just beginning. Even without a record of their route, it is hard to imagine that the high wheelers rode the hill behind them. (Courtesy of California Historical Society, FN-06001.)

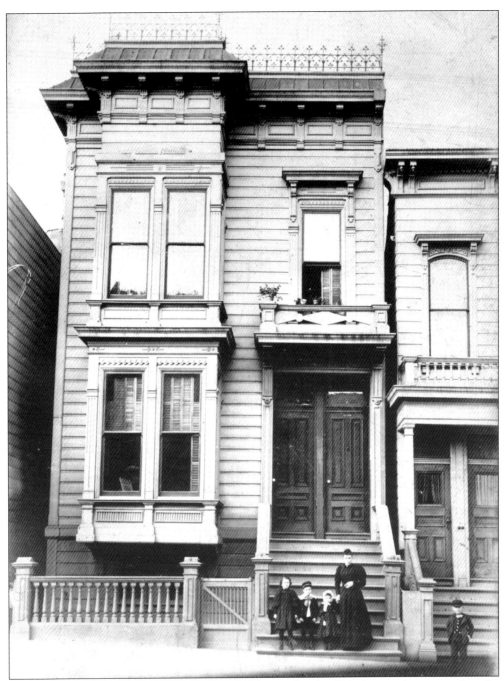

Catherine Kenny Loftus, a Galway native and former South of Market resident, moved to the Mission with her husband and young family. In 1897, she stands in front of the family flats at 3390–3392 Twenty-second Street with her children Evelyn, George, and Martha. Kate appreciated her new life. She planted a lilac bush in her backyard and hung cedar shutters at her windows. She particularly enjoyed getting to know people from other immigrant groups, and her advice to newcomers was to "mix." Her home has been drastically altered, but the doors on the house next door are still the same. (Courtesy of Loftus family.)

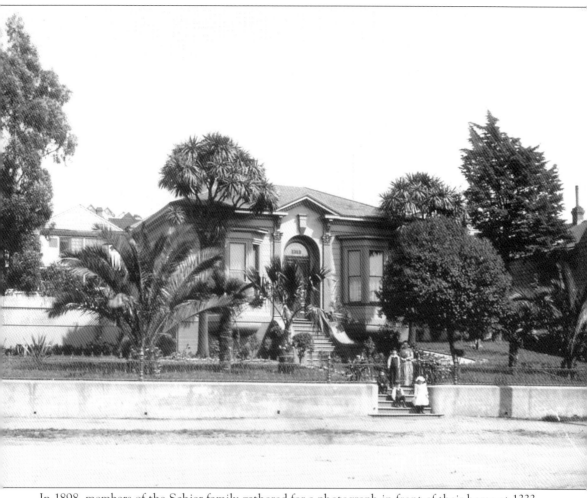

In 1898, members of the Schier family gathered for a photograph in front of their home at 1333 Vermont Street, near Twenty-third Street. Constructed about 1870, the home had large rooms with 10-foot ceilings. There was a carriage house, laundry house, chicken coops, and a machine shop. On the grounds were century plants, palm and apple trees, and a large fishpond. However, progress overtook the property, and along with other houses in the area, it made way for the new Bayshore Freeway. Since the 1950s, it has been the site of hospital curve, that stretch of freeway east of San Francisco General Hospital. (Courtesy of Schier family.)

As the neighborhood filled up, many congregations built places of worship. The community of St. James Church at Twenty-third and Guerrero Streets was started in 1888. This first communion photograph dates to 1900. Soon after the church was constructed, Father Lynch, pictured above, sent a parishioner to the top of a nearby hill to see if the cross on the steeple was straight. (Courtesy of Loftus family.)

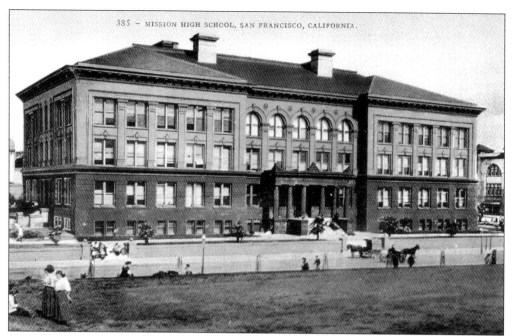

Mission High School was founded in 1890. It has had many notable graduates, including Robert Gordon Sproul, class of 1904, president of the University of California; John Shelley, student body president in 1922 and later congressman and mayor; J. Eugene McAteer, a state senator; and musician Carlos Santana. (Courtesy of Mission High School Alumni Museum.)

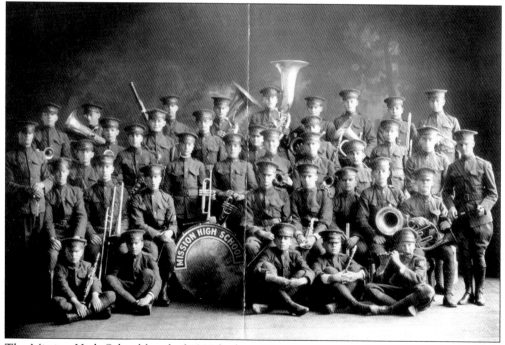

The Mission High School band of 1900 had a military appearance. For a young school, it had already established many activities to keep its students busy outside of class. (Courtesy of Mission High School Alumni Museum.)

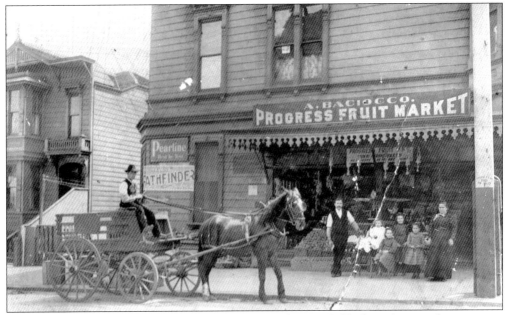

Anthony Baciocco came to San Francisco from Paggi, Italy, in 1887. His first job was with a scavenger company. He did not like the work, but his coworkers, Louie and Carling Muzio, introduced him to their sister Rosa, his future wife. Antonio worked for many years at produce farms in Glen Park before he opened his Progress Fruit Market on Twenty-fourth Street at Guerrero Street, where Antonio and Rosa raised their six children. (Courtesy of Baciocco family.)

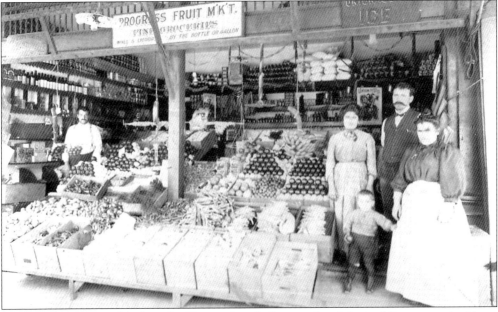

At the Progress Fruit Market, the Twenty-fourth Street side of the building opened wide to display the Baciocco family's produce. Antonio Baciocco grew his produce on two lots he owned in Lomita Park (now Millbrae). He also sold wine by the bottle or the gallon. During the fire that followed the 1906 earthquake, he took his family to the peninsula until he was sure it was safe for them to return to the city. (Courtesy of Baciocco family.)

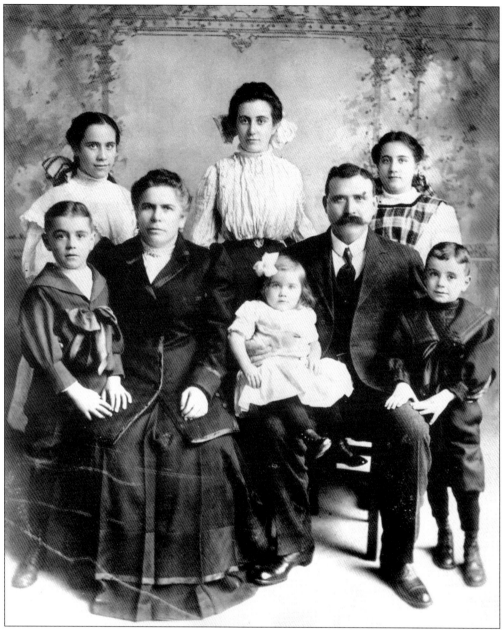

This early photograph of the Baciocco family shows, from left to right, (first row) Albert, mother Rosa, Florence, Antonio, and Frederick; (second row) Elizabeth, Elvera, and Mary. Rosa spoke mostly Italian with her children and grandchildren. Antonio spoke only English with them. Aside from being a family man and a merchant, Baciocco is remembered for his neighborly works. Each Monday, he drove Father Lynch of nearby St. James Church to the Bank of America at Twenty-third and Mission Streets to deposit the Sunday collection. (Courtesy of Baciocco family.)

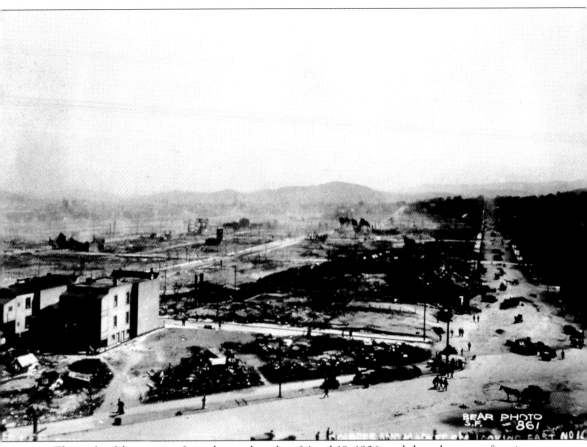

The scale of devastation from the earthquake of April 18, 1906, and the subsequent fires is seen from Market and Dolores Streets. The firestorm spread as far south as Twentieth Street. The remaining part of the neighborhood was saved by the heroic efforts of firefighters and residents, who fought the flames on the streets and beat out embers on rooftops with only one working fire hydrant in the area at Twentieth Street and Church. In recognition, the hydrant is spray painted gold every April 18. (Courtesy of California Historical Society, G-1475.)

Two

EARTHQUAKE AND FIRE

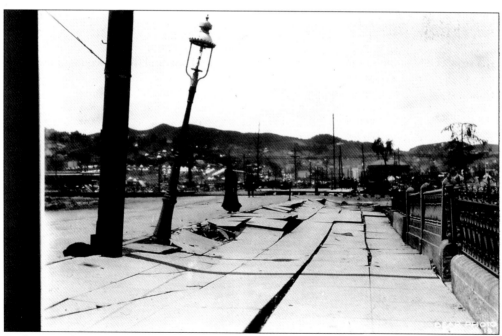

In this view from Eighteenth and Capp Streets, the outline of Twin Peaks is familiar, but many neighborhood buildings are gone. To the west is Mission High. Tracks in the foreground were laid for the trains that removed debris from downtown and carried it to dumping grounds. (Courtesy of California Historical Society, G-1601.)

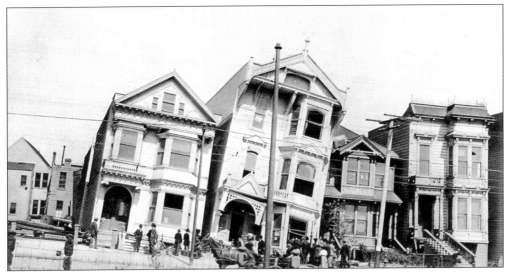

This scene on Howard (later South Van Ness) near Eighteenth is an example of what happened to areas built over unstable ground. In the Mission District, that was the dry lagoon bed and the active creek system. They did not use the term liquefaction at the time, but they quickly understood that location made a difference in the possibility of this type of destruction. (Courtesy of Paul C. Ryan.)

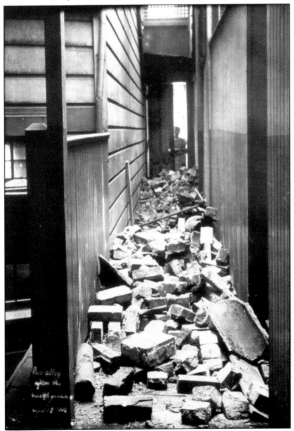

Soon after the quake, Charles Ehrer of 501 Capp Street was busy communicating with Mrs. C. Ehrer, or "T," in Los Angeles by way of picture postcards. This one showed the rubble of their fallen chimney in the alley. Most of the writing was in French and ended with "Kisses, Charles." (Courtesy of California Historical Society No. FN-34495.)

This typical neighborhood scene was enacted in front of the Ehrer family home each day as cooking was done outdoors. This postcard dated April 21, 1906, reads, "Order du Jour: (order of the day): Everyone cooks outside—no fires are allowed indoors. Our temporary stove made from the bricks of our chimney." (Courtesy of California Historical Society FN-34485.)

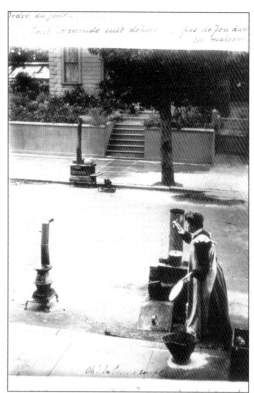

The Gray and Sullivan families of Twenty-second and Florida Streets gathered on the street with their neighbors in the months following the earthquake and fire. (Courtesy of Gray family.)

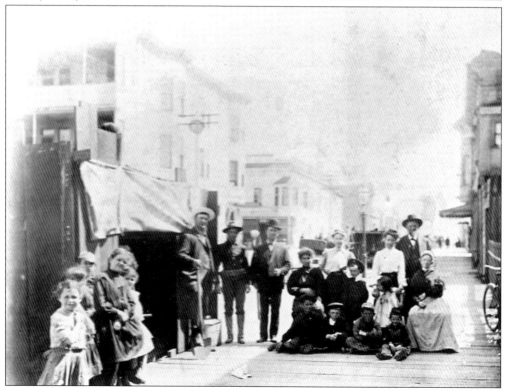

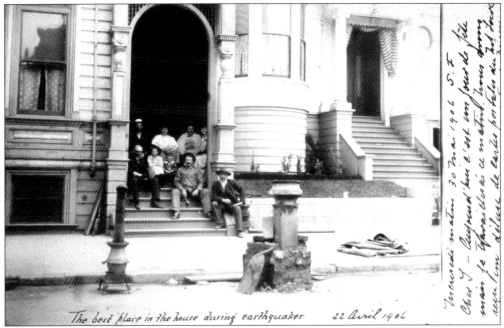

The best place in the house during earthquaker 22 avril 1906

The front steps at 501 Capp Street were the "best place in the house during an earthquake," according to Charles Ehrer. The text reads, "Wednesday Morning, May 30, 1906, SF. Dear T, Today is a holiday but I worked this morning. We have had a flood of postcards from (?) truly an homage to bad times. Kisses, Charles." (Courtesy of California Historical Society, FN-34500.)

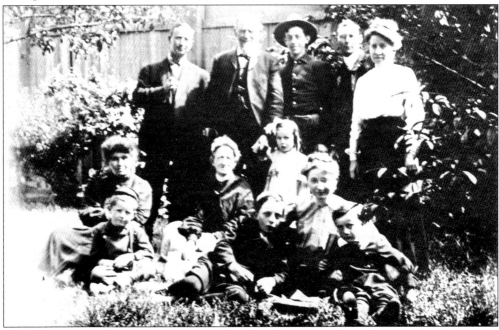

In their backyard, the Grays and the Sullivans had time for a relaxed group photograph. William Gray (back row, left) was an immigrant from Christchurch, New Zealand. He married the Sullivan's daughter Anna Rebecca (back row, right) and moved in with her family. Frank Sullivan, seen here in uniform, would die in the 1918 flu epidemic. (Courtesy of Gray family.)

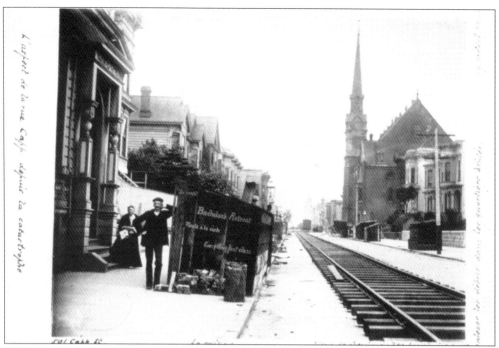

Taken at 501 Capp Street in San Francisco, this April 29, 1906, photograph postcard translates as, "Capp Street scene after the catastrophe. Railroad built to remove the debris in the burned area." (Courtesy of California Historical Society, FN-29124.)

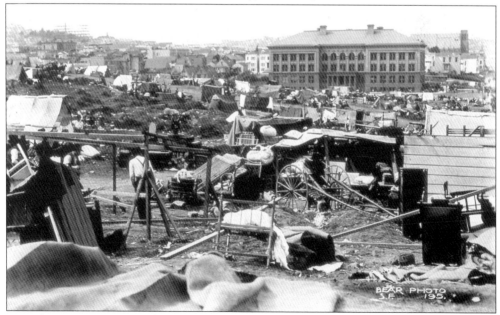

Fire refugees retreated to parks and setup camp. Mission Park, now called Dolores Park, on Dolores Street between Eighteenth and Twentieth Streets, was at the edge of the fire area. Conditions at temporary camps improved when neat rows of earthquake shacks were setup. Through the dedicated efforts of preservationists, some of these structures still survive, largely in the Sunset District. (Courtesy of California Historical Society, G-1379.)

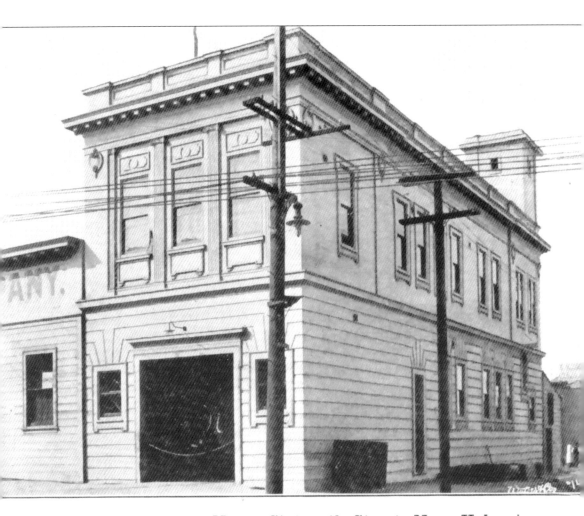

House of Engine Company No. 7, Sixteenth Street, Near Valencia.

Part of the rebuilding of the city included replacement of city services. A new firehouse was constructed on Sixteenth Street near Valencia Street. The building is still there but is now used for a different purpose—a bar. (Courtesy of Simon family.)

Three

REBUILDING A
NEIGHBORHOOD AND
A CITY

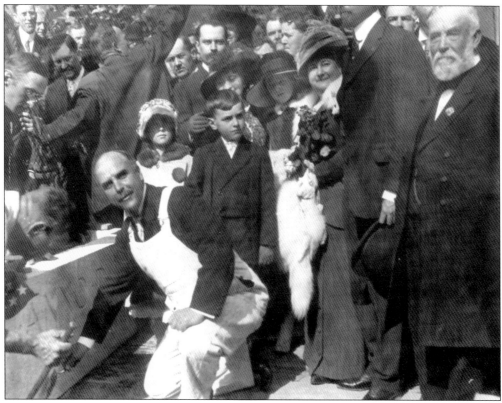

James Rolph Jr., best known as Mayor "Sunny Jim" Rolph, kneels to lay the cornerstone of the new city hall on October 1913. He was mayor from 1912 until 1931, when he became governor. Pictured with him are his children, James Rolph III, Georgina Rolph, and Annette Rolph. The family resided at Twenty-fifth Street and San Jose Avenue. Their home was torn down many years later, and modern buildings now wrap around that corner. It is said that Rolph's flagpole is still there, in one of the backyards. (Courtesy of California Historical Society, FN-04314.)

Fr. Peter Yorke, a native of County Galway, came to San Francisco as a young priest. He became the editor of the Archdiocesan paper, a champion of the workingman, and pastor of St. Peter's Church in the Mission District. During one tense labor conflict, the governor paid a visit to Father Yorke at St. Peter's rectory. This photograph stood on his secretary's desk for many years. (Courtesy of Archives for the Archdiocese of San Francisco.)

James Phelan lived on Valencia and Seventeenth Streets with his mother and sister until their home was destroyed by the earthquake and fire. A past mayor and future senator, Phelan was one of the most influential men in the city and helped organize its rebuilding. (Courtesy of California Historical Society, FN-16837.)

Patrick H. Loftus and his wife's cousin, Patrick R. Ward, enjoyed a moment of mock conflict around 1910. They lived around the corner from each other at 3392 Twenty-second Street and 981 Guerrero Street. Loftus was a porter at the Occidental Hotel until April 18, 1906. After that, he worked for the belt railway on the Embarcadero. Ward was a contractor. Both have workingmen's tans that end at the collar. (Courtesy of Loftus and Ruane families.)

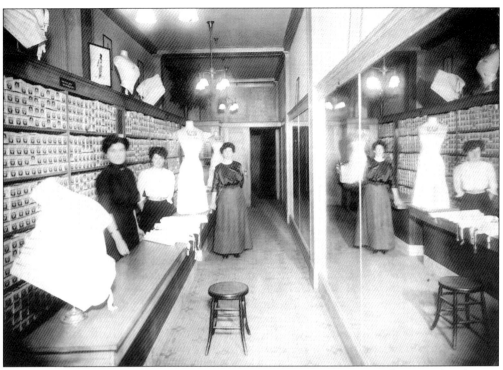

Annie Killeen, in the white blouse, worked at a Mission Street corset shop in the early years of the 20th century. She married Fred Ross, a young man from the neighborhood, and raised her children on Bartlett Street. (Courtesy of Linda Moller Ruge.)

When Annie Killeen became Annie Ross and moved to an apartment at 539 Capp Street, she ordered furniture from Gullixson's at Market, Church, and Fourteenth Streets (the present-day location of a Safeway parking lot). Her 1913 invoice gives an idea of what a young householder needed in that era. (Courtesy of Linda Moller Ruge.)

Mission District native Mary de Guerrero, also known as Seniorita Carmelita, had a long and very successful career as a Spanish dancer. In 1914, a local promoter called her one of the "cleverest Spanish dancers" and praised her "poetry in motion." Mary was a granddaughter of Francisco de Guerrero, who served Yerba Buena as alcalde, a combination justice of the peace and mayor. Guerrero and his family lived at Mission Dolores. His descendants still reside in the area. (Courtesy of Donna Gurule.)

John McEnnerney and his sister Kate Hamill pose in front of their home at 2862 Harrison Street, c. 1918. The siblings immigrated from County Cavan, Ireland, in the 1870s and settled in the mining town of Leadville, Colorado, where they ran a boardinghouse. In 1907, they made their final move to San Francisco to assist a widowed cousin and her infant. (Courtesy of McEnnerney family.)

Irish-born Thomas Bell (1839–1917) had several careers: escort for early settlers on the Overland Trail, stevedore on the San Francisco waterfront, and builder. He was frequently confused with a well-known financier of the same name. The other Mr. Bell made many trips to Hampshire Street to collect his misdirected mail. The sight of the financier's elegant carriage was a thrill for the neighbors. (Courtesy of Bell and Emberton families.)

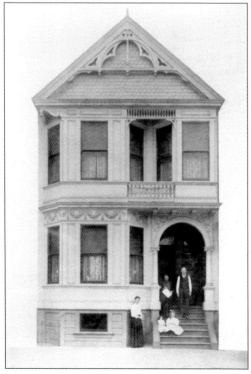

Thomas Bell relocated to this set of flats at 964–968 Hampshire Street after his family lost their South of Market home on Gilbert Street to the earthquake and fire. His daughter Mamie Bell Phelan, left, was widowed early. Mamie had a long career as a music teacher and inspired the composition *Moonlight at the Cliff, A Reverie* by admirer S. Seiler. His other daughter Catherine Bell Emberton is also pictured here with little Etienne Emberton, her daughter. (Courtesy of Bell and Emberton families.)

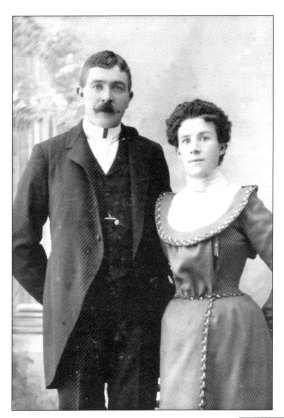

Patrick and Mary O'Connor Hession immigrated from County Galway, Ireland, and settled on Twenty-first Street near Guerrero Street. Patrick was a plasterer and relocated his family several times to follow building booms throughout California. His last career was as a gardener in Golden Gate Park. (Courtesy of Hession family.)

Mae, Theresa, and Dolly Hession, children of Patrick and Mary, are in the front yard of their home at 3371 Twenty-first Street, c. 1907. The photograph was probably taken in the morning, since the sun is in their faces. The fog, if any, burns off early in the Mission District. (Courtesy of Hession family.)

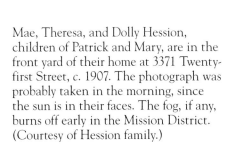

A neighbor took this photograph of the Hession family home at 3371 Twenty-first Street. It can be dated to the 1909 political season from the poster in the upper window for P. H. McCarthy. McCarthy ran for mayor that year and served in that capacity from 1910 to 1912. He was succeeded by James Rolph Jr. (Courtesy of Hession family.)

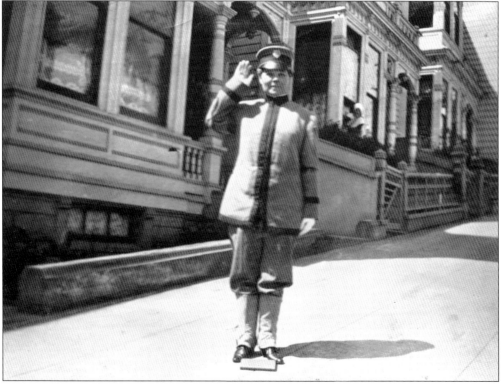

In the early 20th century, a female telegram messenger salutes the camera in front of Mary Durkin's house at 3367 Twenty-first Street. As is common for casual images, the subject's name was not noted. Perhaps she was a friend or she had just delivered good news. (Courtesy of Hession family.)

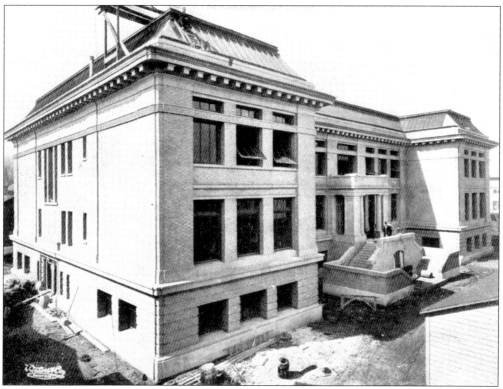

Mission Grammar School, located on Mission Street between Fourteenth and Fifteenth Streets, at one time had 17 classes. (Courtesy of Emberton family.)

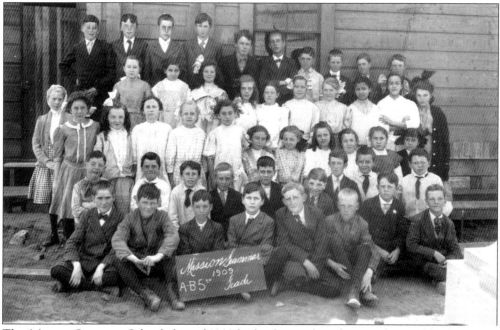

This Mission Grammar School class of 1909 had a dirt yard to play in. The neighborhood had still not recovered from the earthquake and fire. (Courtesy of Emberton family.)

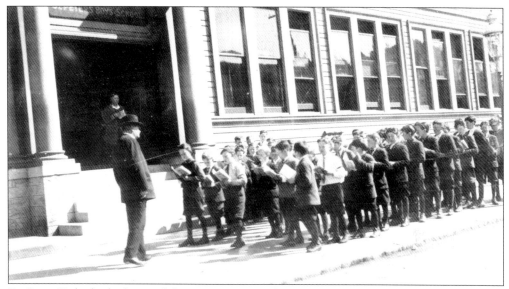

Fr. Peter Yorke had advanced degrees at a time when many people did not even attend high school. In recognition of his standing in the community, Father Yorke was appointed to the Board of Regents of the University of California. His immediate educational interests were closer to home, though, with the children of St. Peter's, his parish school. (Courtesy of Archives of the Archdiocese of San Francisco.)

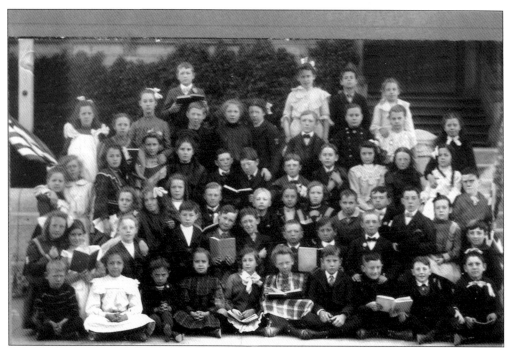

Columbia Grammar was on Florida between Twenty-fifth and Twenty-sixth Streets. Gustav E. Schier is seated in the front row (right corner). He served in World War I, came home, and married a girl from the neighborhood. (Courtesy of Simon family.)

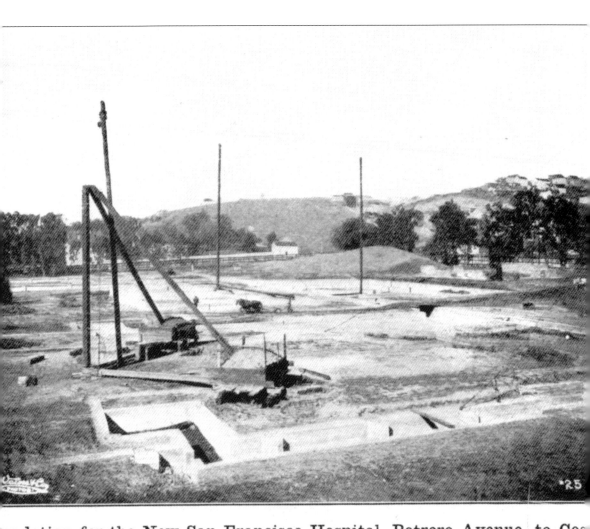

undation for the New San Francisco Hospital, Potrero Avenue, to Cos
$2,000,000 When Completed.

One of the city services targeted for replacement or enlargement was San Francisco General
Hospital. This empty lot was a good start. (Courtesy of Simon family.)

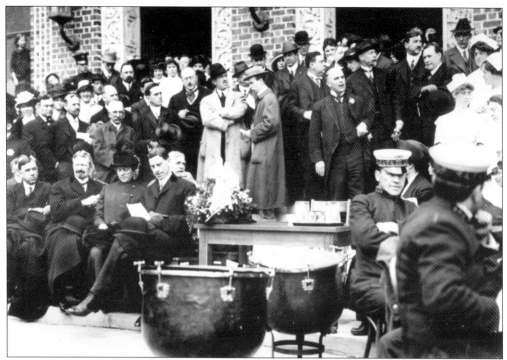

The official opening of the new hospital buildings took place with a band, the staff, and the presence of Mayor Sunny Jim Rolph, center. (Courtesy of San Francisco General Hospital.)

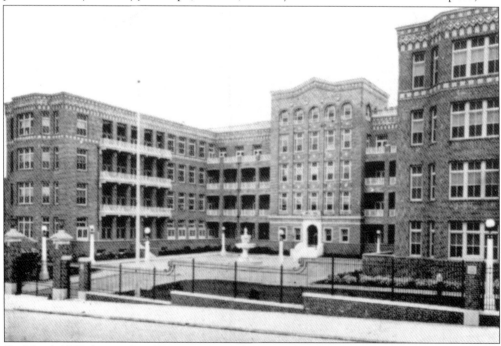

On May 1, 1915, the new San Francisco General Hospital buildings were dedicated. More extensive than original hospital, it was another 50 years before the third expansion of the facilities took place. Note the complicated design of the brickwork. (Courtesy of San Francisco General Hospital.)

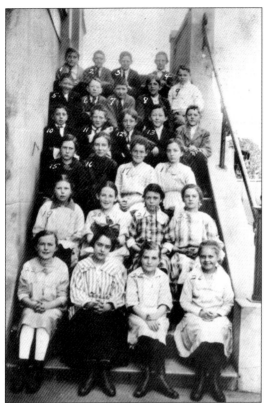

The class of 1919 at St. Anthony School included children whose families had lived in the neighborhood for decades. On the reverse side are names that correspond to the numbers on the front. Here are a few: William Knight, 2; Paul Kroll, 4; John Clifford, 7; Hugh Donohue (future Bishop), 13; Julia Connelly, 17; Mary Walsh, 23; and Anna Kreusz, 26. (Courtesy of St. Anthony-Immaculate Conception School.)

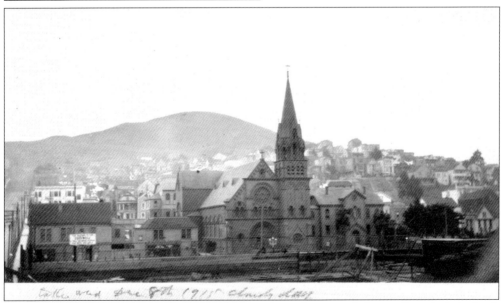

St. Anthony of Padua Parish Church, located at Army Street and Shotwell, included a high proportion of German-born parishioners. The original structure was lost to a fire in 1975, but its stone portico survives and can be seen in front of the new church. One of the facts gathered for the school roster in 1900 was the country of origin of each student's father. On one page, 11 countries were represented. (Courtesy of St. Anthony-Immaculate Conception School.)

Minni Hausler lived at 2956 Harrison Street. This photograph was taken in the early 20th century when there were still wooden sidewalks in that part of the neighborhood. Her lace curtains were a sign of the middle class. (Courtesy of St. Anthony-Immaculate Conception School.)

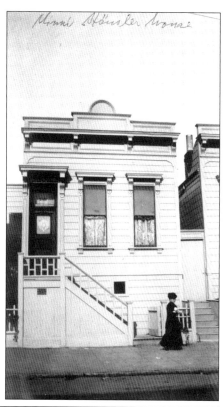

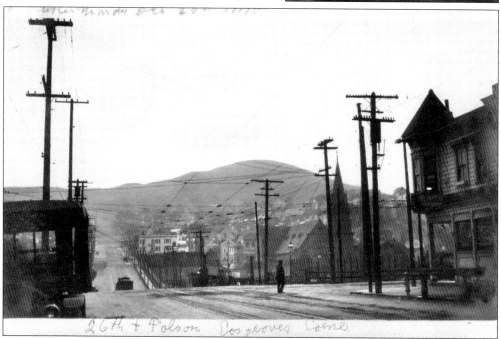

One of the first plank roads in the Mission was on Folsom Street. This 1915 photograph shows streetcar tracks climbing Folsom Street on the north side of Bernal Heights. (Courtesy of St. Anthony-Immaculate Conception School.)

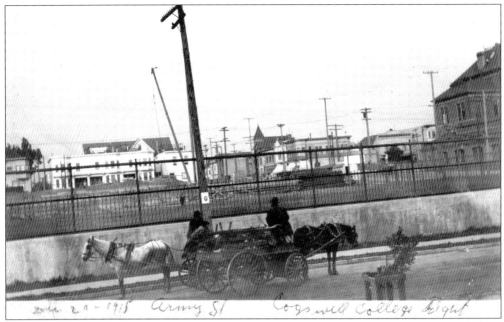

Sep. 20 - 1915 Army St Cogswell College Right

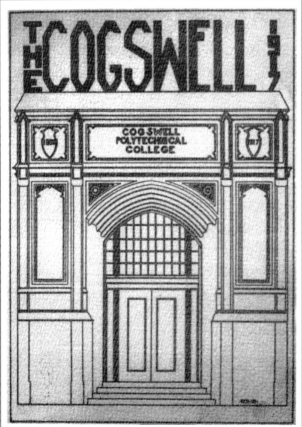

THE COGSWELL 1917

COGSWELL POLYTECHNICAL COLLEGE

Printed from original plate
c.1917

Cogswell College was founded in 1888 as a high school to provide technical training for boys and business training for girls. It had two locations in the Mission, on Army and Folsom Streets and Folsom and Twenty-sixth Streets. A young man who trained there before World War I went on to work for *Southern Pacific* magazine, a precursor to *Sunset* magazine. He was successful even though he often cut classes and provided faked notes from his mother, penned by his oldest sister. (Courtesy of St. Anthony-Immaculate Conception School.)

Perhaps this cover for a Cogswell College publication, a piece of art in itself, was drawn by a graduate. Cogswell moved from the Mission District in the 1970s. It is now in Sunnyvale, where it maintains its technical training goals. (Courtesy of St. Anthony-Immaculate Conception School.)

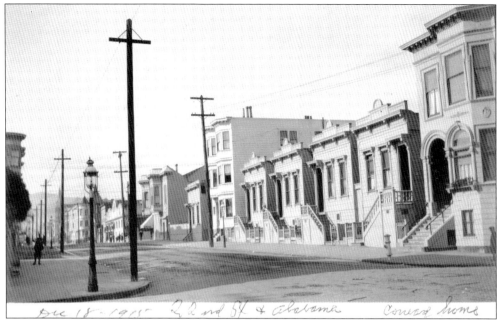

The view of Twenty-second Street and Alabama on December 18, 1915, includes ornate street lamps. At the time, they were considered utilitarian. Now at least one neighborhood street, Liberty Street, has installed street lamps that have the look of earlier days. (Courtesy of St. Anthony-Immaculate Conception School.)

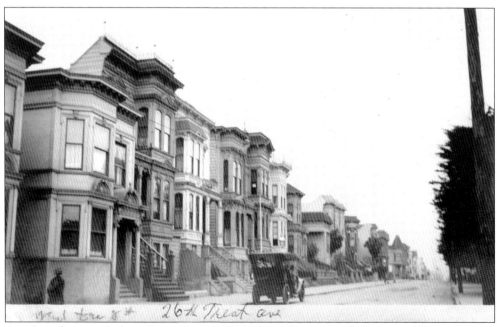

Another photograph from December 18, 1915, shows Twenty-sixth Street and Treat Avenue. Residents of this part of the Mission had diverse occupations: butchers, laborers, electricians, importers, sugar workers, tailors, teamsters, and builders—all occupations needed to rebuild a city. (Courtesy of St. Anthony-Immaculate Conception School.)

GRAND THEATRE

2605 MISSION STREET

MISSION AND TWENTY-SECOND STREETS

F. I. MAHONEY - - - - - Proprietor

SUNDAY, JUNE 18, 1919

ONE DAY ONLY
BEN WILSON
IN
"WHEN A WOMAN STRIKES"

MONDAY AND TUESDAY
WILLIAM DESMOND
IN
"THE PRODIGAL LIAR"

WEDNESDAY AND THURSDAY
MADGE KENNEDY
IN
"DAY DREAMS"

CHARLIE CHAPLIN
IN
"SHANGHAIED"

FRIDAY AND SATURDAY
MARION DAVIES
IN
"GETTING MARY WORRIED"

PRICES: ADULTS, 11c; Children, 6c

Mission District residents enjoyed movies. This 1919 advertisement for the Grand Theatre featured a Charlie Chaplin film and Marion Davies, too. (Courtesy of private collector.)

Henry Patrick McKenna was born in 1907 and grew up on Twenty-fifth Street. Widowed early, his mother, Sarah, went to work for the judges at city hall and built a good life for a small boy—Henry attended nearby St. James School, they traveled extensively with friends from work, and she enrolled him in a junior membership at the Olympic Club. (Courtesy of McKenna family.)

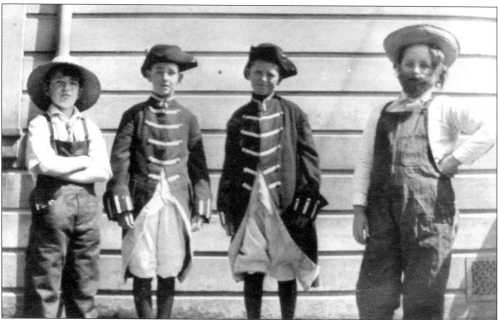

At St. James Boys School in 1918, the "closing exercises" featured a play with performances by, among others, Henry McKenna, left. The name of the play is unknown, but the actors appear to be Redcoats and farmers. Henry's instructors at St. James were the Brothers of Mary. (Courtesy of McKenna family.)

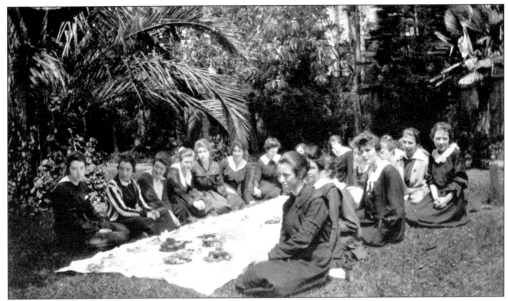

Notre Dame de Namur on Dolores Street near Sixteenth Street was a Catholic girls' school. The graduating class of 1917 had a picnic in the extensive gardens behind the school. The building is now used for a retirement community. (Courtesy of Etienne Simon.)

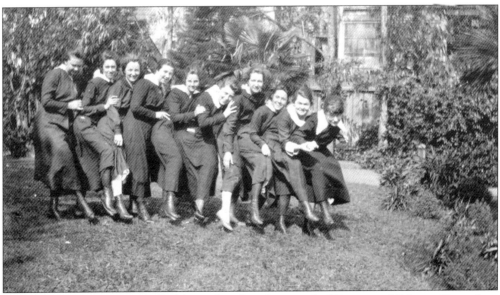

The graduates are in a more playful mood in this photograph. (Courtesy of Etienne Simon.)

In 1883, Immaculate Conception Academy, an all girls' school, was founded at Twenty-fourth Street and Guerrero Street by the Dominican Sisters of Mission San Jose. It is the oldest high school in the Mission. At one time, most of the sisters were from Germany and some were from Mexico. One art instructor, a native of Aachen, joined the convent after she completed her studies at the Sorbonne. (Courtesy of Immaculate Conception Academy.)

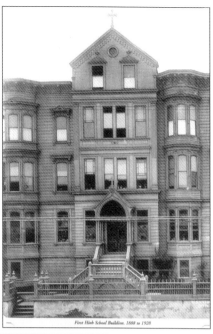

First High School Building, 1888 to 1928

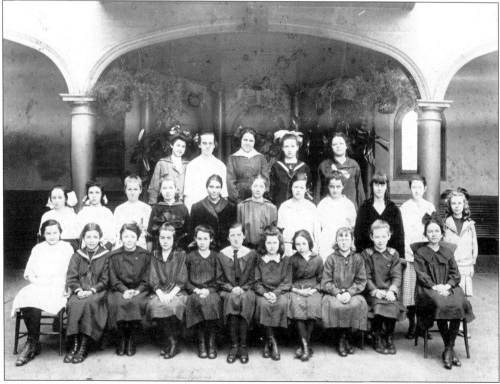

The Immaculate Conception Academy class was photographed in 1916 at the garden level arcade of the Fair Oaks Street music building. Theresa Hession, front row, fourth from the left, went on to a long career as an assistant to San Francisco supervisor James Sullivan. In later years, Theresa operated an insurance agency on West Portal Avenue. (Courtesy of Hession family.)

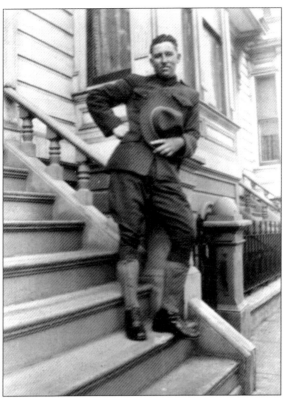

On Twenty-fifth Street, a neighbor and friend of the McKenna family posed in uniform for this photograph, around the time of the First World War. (Courtesy of McKenna family.)

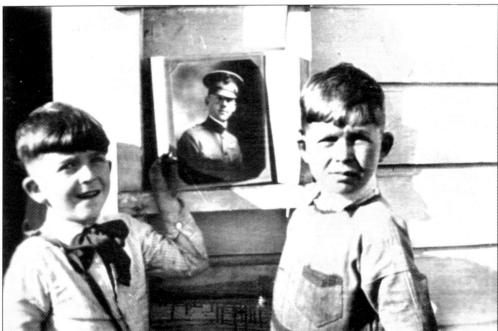

Frank and John Dunnigan, Twenty-first Street residents, are pictured here during World War I with a photograph of Joseph Hession, their neighbor in uniform. Frank appears to be saluting. (Courtesy of Hession family.)

Lawrence Ruane almost didn't make it to America. A younger relative's Irish passport was delayed, and they missed their boat—the Titanic. A few years later, Lawrence, by then a resident of the Mission, joined the United States Army and served as an aviator. He returned to live at 981 Guerrero Street and became a carpenter and later a firefighter at the Drumm Street Station. Lawrence played the fiddle, and he delighted his great-nieces with quaint sayings such as "this is the set up." (Courtesy of Ruane family.)

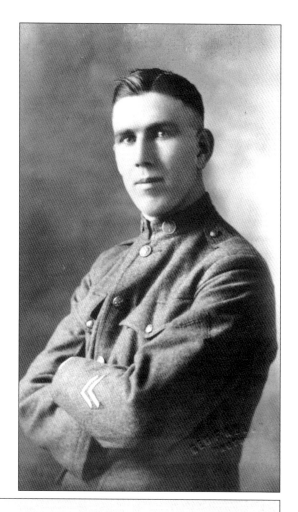

PHONE MISSION 4405

L. J. RUANE

981 GUERRERO ST. SAN FRANCISCO

Lawrence Ruane had a calling card, a necessity for a young man of his era.

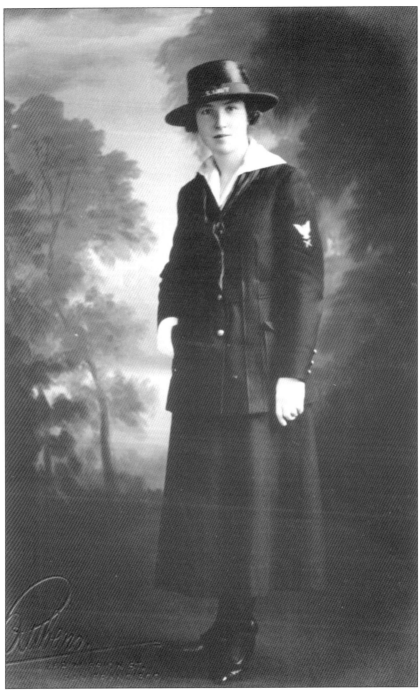

Etienne Emberton, a 1917 graduate of Notre Dame de Namur, joined the U.S. Navy as a yeomanette and was stationed at Mare Island. A busy and accomplished woman, Etienne married, raised a family, earned a law degree, taught genealogy, and started the library at Bryant Elementary School. During World War II, she was an inspector for the navy at the Alameda Air Station. Her family still has her uniform hat, which is in great shape although the grosgrain band, gold-stamped "U.S. Navy," has faded. (Courtesy of Etienne Simon.)

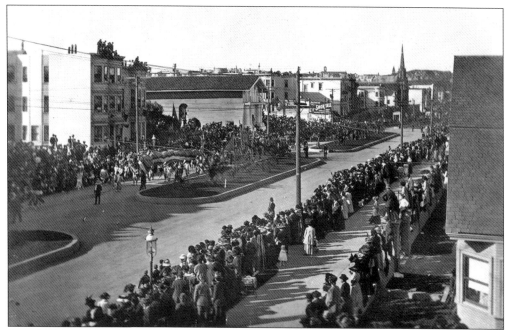

In a show of patriotism, German American Catholics had a military parade on Dolores Street around the time of World War I. This photograph was taken from Seventeenth and Dolores Streets looking northwest. Note the missing parish church for Mission Dolores, destroyed by the 1906 quake and not yet replaced, the small palm trees, and the gaslights. (Courtesy of Archives for the Archdiocese of San Francisco.)

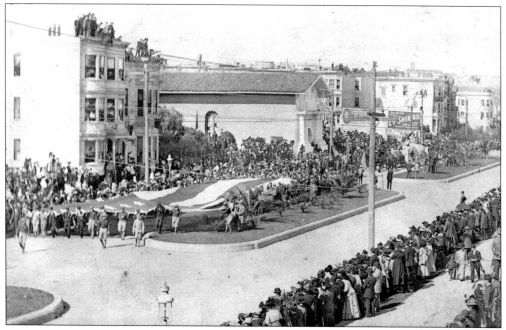

An enormous American flag, possibly a quarter block long, was carried along Dolores Street during the parade. The parade was a popular event, attracting a large group of spectators on the street and on rooftops. (Courtesy of Archives for the Archdiocese of San Francisco.)

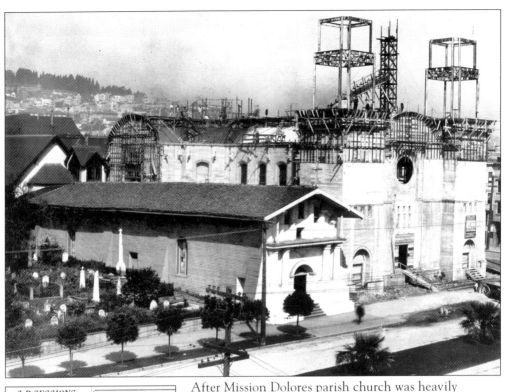

After Mission Dolores parish church was heavily damaged in the 1906 earthquake, it had to be torn down. The new parish church, characterized by a Spanish Baroque style, rose in its place. The construction site is bathed in sunshine. The cemetary does not yet have a wall. (Courtesy of Archives for the Archdiocese of San Francisco.)

The *Mission Enterprise* was published on Twenty-second Street and specialized in bits of neighborhood social and business news, legal notices, and advertisements. The June 6, 1919, edition contains stories about returning servicemen, the graduation delay at Mission High School due to the flu epidemic, and plans for a new roadbed on Valencia Street. (Courtesy of Ruane family.)

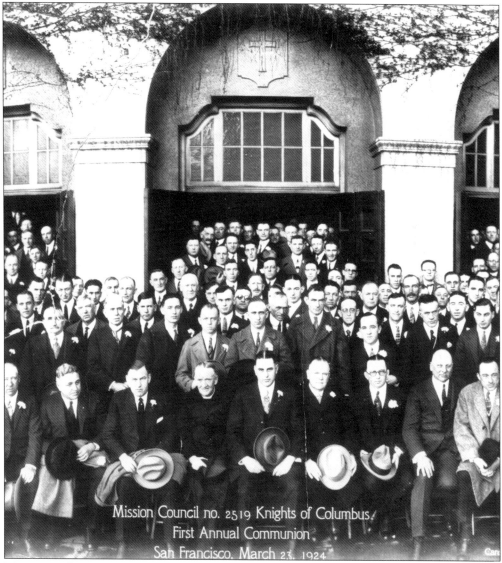

Mission residents were big "joiners." This 1924 photograph of the Knights of Columbus was taken in front of St. Charles Church at Eighteenth Street and South Van Ness. There was an organization for every aspect of one's identity: trade, family, faith, and national origin. The Odd Fellows and the Masons had local halls, as did the Sons of Norway. (Courtesy of Ruane family.)

Price - - - 35 Cents

California Edition

How to Become
AN
AMERICAN
CITIZEN

By

J. MUNSELL CHASE

CONTENTS OF THIS BOOK:

Naturalization Laws of the U. S.
Constitution of the U. S.
Declaration of Independence.
Articles of Confederation.
Questions and Answers usually asked by the Judge.

THE HOLMES BOOK CO.

SAN FRANCISCO, CAL.

1920

Chase & Rae 1185 Church Street

In 1920, a Mission resident and World War I veteran studied this book for his citizenship test. The book was printed on Church Street by union labor. A real pack rat, he kept a keg of nails in his basement for decades, "just in case." His relatives are particularly glad that he kept this memento. (Courtesy of private collection.)

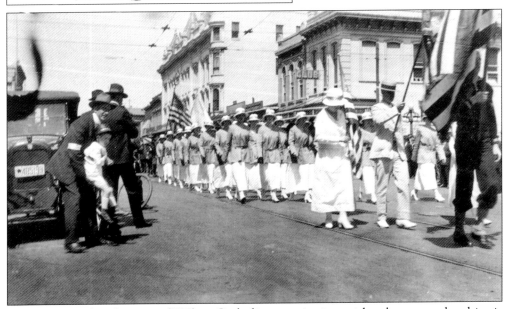

The Young Ladies Institute (YLI), a Catholic organization with a large membership, is pictured here on parade around 1925. There was also a Young Men's Institute (YMI). (Courtesy of private collection.)

In the Mission District, many class pictures were taken outdoors because of the normally good weather conditions. The St. Peter's School first-grade class of 1922 was no exception. (Courtesy of Frank Dunnigan.)

This photograph of children at the Holy Family Day Home dates to the 1920s. It is one of the oldest institutions of its kind in San Francisco and is still located at Sixteenth and Dolores Streets. (Courtesy of Archives for the Archdiocese of San Francisco.)

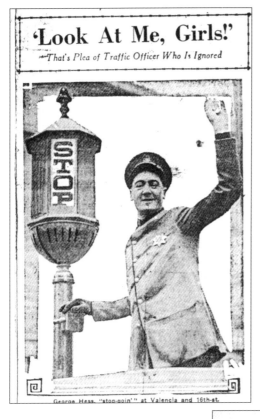

George Hess, "stop-goin'" at Valencia and 16th-st.

George Washington Hess was a Mission District police officer who operated the traffic light at Sixteenth and Mission Streets for decades. He was well liked by his fellow officers, who gave him a pet monkey. More importantly, he was quick to action. One day in 1925, he stopped a runaway horse and wagon. It was "the bravest thing" one eyewitness ever saw. His letter recounting the event is treasured by Hess's extended family. Hess served the Mission District from 1923 until retirement in 1962. (Courtesy of Herbert Simon family.)

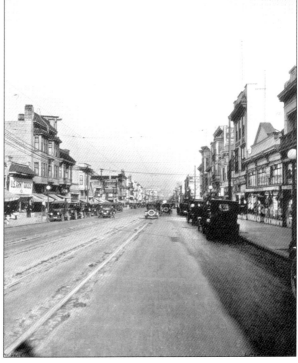

In 1925, Mission Street, particularly from Sixteenth to Nineteenth Streets, had many furniture stores. It still does. For generations, locals wondered why Redick's had "17 Reasons Why." No explanation has ever been satisfied. Many Jewish merchants had businesses on Mission Street and lived nearby. It was also a short walk to the B'Nai David Synagogue on Nineteenth Street, founded in 1906. (Courtesy of California Historical Society, FN-08498.)

The Mission Merchants Association understood shopping incentives—shoppers would fill this book with stamps received for purchases and apply the completed book toward more purchases. In addition to pages for the stamps, this book also contained 13 advertising pages for participating stores, such as the Bee Hive Millinery, The Golden Rule, The Comeback, and The Famous, which sold underwear. (Courtesy of Simon family.)

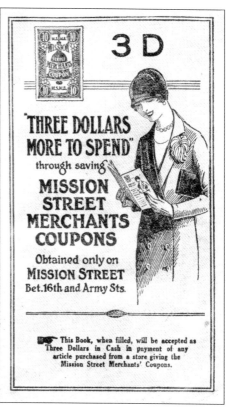

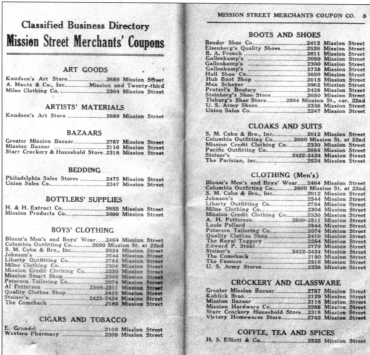

Classified Business Directory
Mission Street Merchants' Coupons

ART GOODS

Knudsen's Art Store	2689 Mission Street
A. Mautz & Co., Inc.	Mission and Twenty-third
Milne Clothing Co.	2304 Mission Street

ARTISTS' MATERIALS

Knudsen's Art Store	2689 Mission Street

BAZAARS

Greater Mission Bazaar	2787 Mission Street
Mission Bazaar	2116 Mission Street
Starr Crockery & Household Store	2318 Mission Street

BEDDING

Philadelphia Sales Stores	2475 Mission Street
Union Sales Co.	2247 Mission Street

BOTTLERS' SUPPLIES

H. & H. Extract Co.	2855 Mission Street
Mission Products Co.	3000 Mission Street

BOYS' CLOTHING

Bloom's Men's and Boys' Wear	2464 Mission Street
Columbia Outfitting Co.	2600 Mission St. at 22nd
S. M. Cohn & Bro., Inc.	2024 Mission Street
Johnson's	2544 Mission Street
Liberty Outfitting Co.	2784 Mission Street
Milne Clothing Co.	2304 Mission Street
Mission Credit Clothing Co.	2330 Mission Street
Mission Smart Shop	2260 Mission Street
Petersen Tailoring Co.	2074 Mission Street
Al Pettersen	2509-2511 Mission Street
Quality Clothes Shop	2410 Mission Street
Steiner's	2422-2424 Mission Street
The Comeback	2180 Mission Street

CIGARS AND TOBACCO

E. Grundel	2100 Mission Street
Western Pharmacy	2399 Mission Street

MISSION STREET MERCHANTS COUPON CO. 3

BOOTS AND SHOES

Bender Shoe Co.	2412 Mission Street
Eisenberg's Quality Shoes	2526 Mission Street
R. A. French	2611 Mission Street
Gallenkamp's	2050 Mission Street
Gallenkamp's	2300 Mission Street
Gallenkamp's	2738 Mission Street
Holl Shoe Co.	3020 Mission Street
Hub Boot Shop	2015 Mission Street
Max Scheyer	2062 Mission Street
Protzel's Bootery	2428 Mission Street
Steinberg's Shoe Store	2650 Mission Street
Tieburg's Shoe Store	2594 Mission St., cor. 22nd
U. S. Army Shoes	2338 Mission Street
Union Sales Co.	2247 Mission Street

CLOAKS AND SUITS

S. M. Cohn & Bro., Inc.	2012 Mission Street
Columbia Outfitting Co.	2600 Mission St. at 22nd
Mission Credit Clothing Co.	2330 Mission Street
Pacific Outfitting Co.	2684 Mission Street
Steiner's	2422-2424 Mission Street
The Parisian, Inc.	2524 Mission Street

CLOTHING (Men's)

Bloom's Men's and Boys' Wear	2464 Mission Street
Columbia Outfitting Co.	2600 Mission St. at 22nd
S. M. Cohn & Bro., Inc.	2012 Mission Street
Johnson's	2544 Mission Street
Liberty Outfitting Co.	2784 Mission Street
Milne Clothing Co.	2304 Mission Street
Mission Credit Clothing Co.	2330 Mission Street
A. H. Pettersen	2509-2511 Mission Street
Louis Pollard	2844 Mission Street
Petersen Tailoring Co.	2074 Mission Street
Quality Clothes Shop	2410 Mission Street
The Royal Toggery	2254 Mission Street
Edward P. Stahl	2779 Mission Street
Steiner's	2422-2424 Mission Street
The Comeback	2180 Mission Street
The Famous	2516 Mission Street
U. S. Army Stores	2338 Mission Street

CROCKERY AND GLASSWARE

Greater Mission Bazaar	2787 Mission Street
Koblick Bros.	2129 Mission Street
Mission Bazaar	2116 Mission Street
Mission Hardware Co.	2288 Mission Street
Starr Crockery Household Store	2318 Mission Street
Victory Homewares Store	2762 Mission Street

COFFEE, TEA AND SPICES

H. S. Elliott & Co.	2525 Mission Street

Two of the 12 pages in the Mission Street Merchants coupon book were devoted to the merchant's directory. (Courtesy of Simon family.)

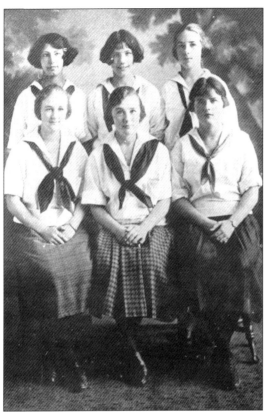

This is a Mission High women's swim team from the 1920s. Since the school has never had a pool, they probably swam at Mission (Nickel) Pool on Nineteenth Street. (Courtesy of Mission High School Alumni Museum.)

John Philip Sousa, bandmaster and composer of over 100 marches, visited Mission High on November 5, 1928. It was a day before his 74th birthday, and the home economics class marked the event by baking a cake for him. (Courtesy of Mission High Alumni Museum.)

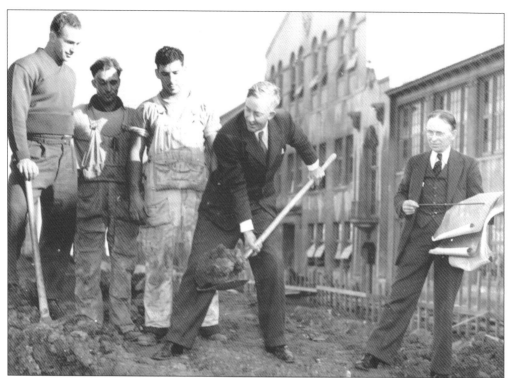

Architects and builders prepare to make improvements to Mission High, c. 1930. (Courtesy of Mission High School Alumni Museum.)

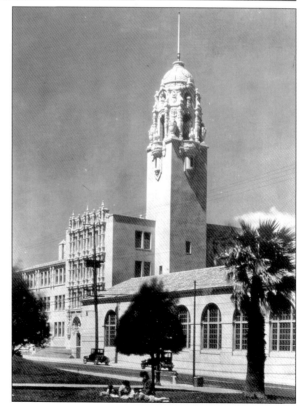

By 1928, the new Mission High building at Eighteenth and Dolores Streets was already grand. Its tiled hallways and WPA-era murals are far from ordinary in a city high school. Alumni are pursuing well-deserved landmark status. (Courtesy of California Historical Society, FN-31925.)

Timothy Pflueger, a noted San Francisco architect, was a lifelong resident of 1015 Guerrero Street. The son of a German immigrant tailor, Timothy and his brothers were very studious, and all became professionals. Timothy designed many important San Francisco landmarks, including 450 Sutter, George Washington High, and City College. As his success grew, he acquired larger automobiles, and the garage he rented from neighbor, Rose Pat, was enlarged to accommodate them. (Courtesy of California Historical Society, FN-0000.)

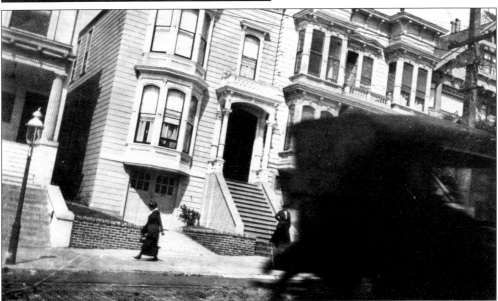

Guerrero Street near Twenty-second Street looks much the same as it did around 1920. At that time, there were streetcar tracks, wider sidewalks, two lanes of traffic, gaslights, and cobblestones. The Palladian-style white house to the left belonged to Congressman Richard Welch. He grew up in another part of the neighborhood. Matthew I. "Matt I" Sullivan, justice of the California Supreme Court, lived on the same block. (Courtesy of Ruane family.)

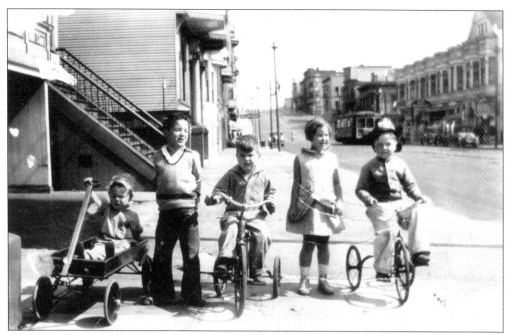

In 1931, these children on Guerrero Street were all smiles for the photographer—neighbor and parish priest Fr. Charles Murphy. Father Murphy was a descendant of the family that founded Murphys, a Gold Country town. Pictured, from left to right, are Tom Tracy, Ed Tracy, Gerald Ruane, Bernadette Ruane, and "a boy from the next block." Note the tracks and trolley in the middle of the street; there were no trees at this time. Later Guerrero Street was lined with flowering plum trees that the neighbors look forward to despite their short bloom time. (Courtesy of Ruane family.)

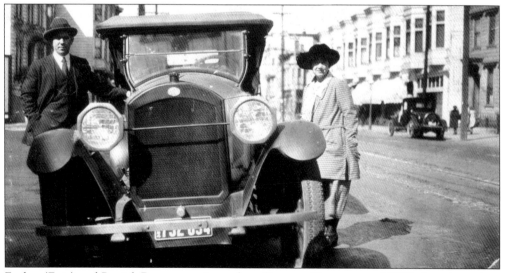

Evelyn (Evie) and Patrick Ruane are pictured on Guerrero Street around 1930. At a time when so many locals were immigrants, Patrick liked to refer to his wife as a "Native Daughter." Evie and her girlhood friends had a Mission accent characterized by a short "A" and a Boston-like intonation. It was most evident when she warned her grandchildren to watch for "the machines" as they crossed the street. (Courtesy of Ruane family.)

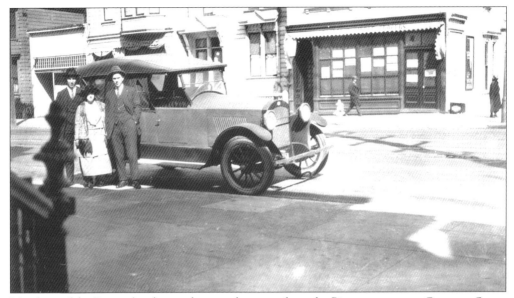

Members of the Ruane family posed across the street from the Pierce grocery on Guerrero Street at Alvarado, owned by Nellie Cox. Mrs. Cox, a widow, lived behind the shop. Frustrated by delays in obtaining a liquor permit, she appealed to Mayor Rolph. The permit came through soon afterwards. The store was later converted into a flat. The building stayed in her family for several generations. Two buildings to the left of the grocery was the home of the Pflueger family. (Courtesy of Ruane family.)

Betty Ross, the daughter of Annie Killeen Ross, posed in her Sunday best in front of the family home on Bartlett, near Army Street. The block eventually made room for the auto department of a Sears store. The house was moved to Bernal Heights. Betty married, had a family, and was a career employee of the San Francisco Unified School District. (Courtesy of Linda Moller Ruge.)

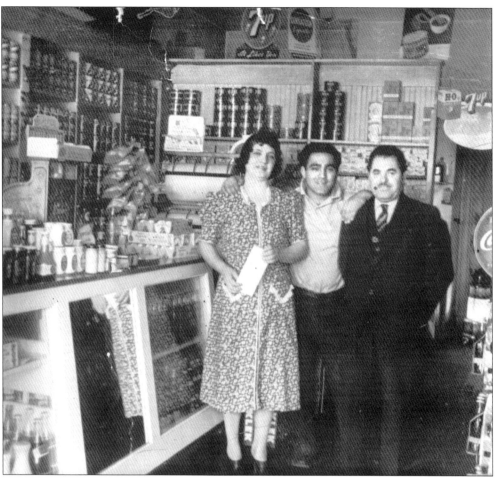

Latify (Lilly) Beiney Hider proudly holds the deed to the Handy Stop Market at Eighteenth Street and South Van Ness that she opened in 1930. With her are her son John and friend and neighborhood barber, Trini Gonzalez. A native of Beirut and the mother of five, Lilly lived to be 103. Trini once left a patron mid shave to give a neighbor a ride to work. He told the patron he would be "right back," and he was. (Courtesy of John Hider.)

Local merchants underwrote an anniversary booklet for St. Charles Church. (Courtesy of Marian Tandy.)

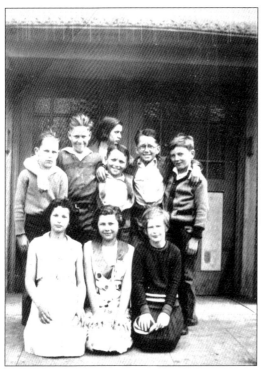

This neighborhood group posed on Treat Avenue in 1932. Pictured here, from left to right, are (first row) Ruth, Elsa, and Helen; (second row) Chester, Keith (Calden, later San Francisco fire chief), Bob, Fred, and Frank; (third row) Margaret Westerhouse, in profile. (Courtesy of Frank Dunnigan.)

The curriculum for the class of 1934 at the St. Charles Commercial School included bookkeeping, typing, and shorthand. They were also schooled in proper business attire and etiquette. During the Depression, some students had to work part-time to pay for high school. Others found jobs soon after. Edna O'Brien, second from right, top row, got an office job with Gerald Simon's millinery company on Market Street. Simon made sure that the staff had many skills. Edna learned how to decorate a hat. (Courtesy of Edna O'Brien Vierucci.)

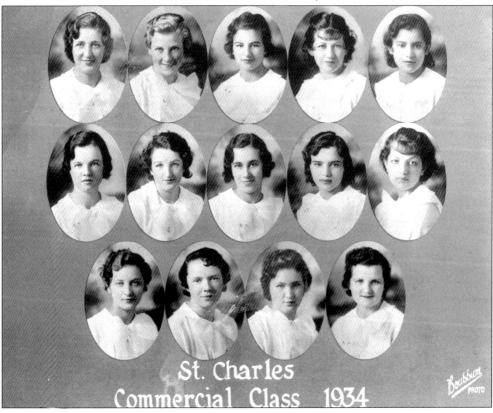

St. Charles Commercial Class 1934

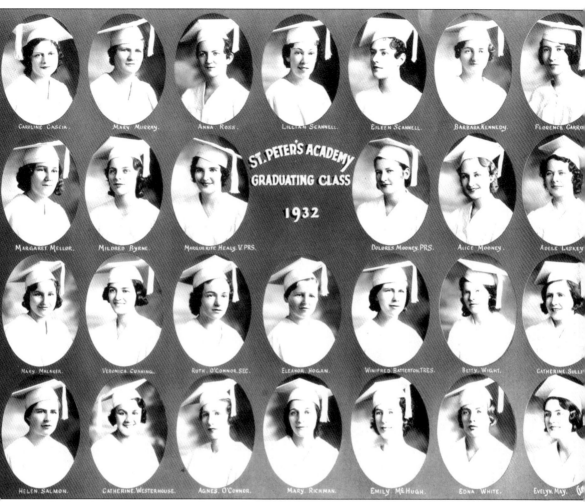

CAROLINE CASCIA. MARY MURRAY. ANNA ROSS. LILLIAN SCANNELL. EILEEN SCANNELL. BARBARA KENNEDY. FLORENCE GARRO

ST. PETER'S ACADEMY GRADUATING CLASS 1932

MARGARET MELLOR. MILDRED BYRNE. MARGUERITE HEALY. V. PRS. DOLORES MOONEY. PRS. ALICE MOONEY. ADELE LASKEY

MARY MALAKER. VERONICA CUSHING. RUTH O'CONNOR. SEC. ELEANOR HOGAN. WINIFRED BATTERTON. TRES. BETTY WIGHT. CATHERINE SULLI

HELEN SALMON. CATHERINE WESTERHOUSE. AGNES O'CONNOR. MARY RICHMAN. EMILY McHUGH. EDNA WHITE. EVELYN MAY.

St. Peter's Academy was another small neighborhood school. This 1932 senior class photograph includes Catherine (later Katherine) Westerhouse, second from left in first row. All St. Peter's students took typing. Katherine remembered that records were played by the teacher to force the students to type in tempo. The musical selections became faster as the course progressed. (Courtesy of Westerhouse family.)

Fulvius,
Thomas Jordon

Agnes,
Ella Hughes

Fabiola,
Frances O'Connor

The St. Charles Players performed *Fabiola* at the Valencia Theatre on October 18, 1910. (Courtesy Julie Lyons.)

THE ST. JAMES PLAYERS
Under the Personal Direction of Mr. D. E. Sullivan
Present

"The Royal Masquerade"
A Comedy in Three Acts

WEDNESDAY EVENING, OCTOBER 25TH, 8:15
FRIDAY EVENING, OCTOBER 27TH, 8:15

Hilbred Sabidoff	Mr. L. Forrest Emerson
Paul Masoch	Mr. Richard Horn
Lydia Petrovic	Miss Rosemary Sullivan
Peter Kraditch	Mr. Frank P. Kelleher
Count Vellenburg	Mr. Bernard J. Ward, Jr.
Sergeant of Police	Mr. Donnel McCarthy
Servant	Miss Patricia Loftus
Elinor, Queen of Moldavia	Miss Katheryne Hedman
Alexis, King of Moldavia	Mr. Robert Halsing
Elizabeth, Queen of Wallachia	Miss Alice Matthews
Nicholas, King of Wallachia	Mr. Francis Hannigan
Katerina, Princess of Wallachia	Miss Virginia Donohoe
Blondel, Secretary to the King	Mr. J. Stanley Gillis

Personnel of the Chorus: Misses Mary Conway, Marie Renner,
Dixie Crowell, Claire Mackey, Anita Valpey, Margaret Britz,
Marion Burke, Patricia Loftus, under the personal direction of
Betty May's Dancing Studio.

Act I. Scene 1—Stage of Municipal Theatre, Baroc, Moldavia.
Scene 2—Room at the Royal Palace, Baroc. The next day.
Act II. Scene 1—The Royal Palace Diniker, Wallachia. Two
weeks later.
Scene 2—The same. The morning after.
Act III. Scene 1—At the Royal Palace Baroc. One month later.
Scene 2—Two hours later.
Time: The present day.

Honorary Chairman	Rt. Rev. Monsignor P. J. Quinn
Chairman	Rev. Jeremiah Gleeson
Music by	The Immaculate Conception Academy Orchestra
Stage Manager	Mr. Joseph Doyle
Assistants	Misses Margaret Kingsley, Ruth McKannay,

Messrs. John Doyle, Vincent Butler, John Walsh, John Fixa,
Patrick Loftus, William Dowling, Thomas Leach, and Harold Porter

ACKNOWLEDGMENTS
Betty May's Studio of Dancing . . 208 Fair Oaks Street
Furniture by courtesy of Lachman Bros. Furniture Co., Sixteenth
and Mission Streets

Amateur theatricals were a popular pastime. This playbill for the St. James Players production of *The Royal Masquerade* shows that they had support from the neighborhood—Lachman Brothers Furniture Company and Betty May's Studio of Dancing. One of the assistants, John Fixa, was not destined for a stage career; he became the U.S. postmaster for San Francisco. (Courtesy of St. James School.)

74

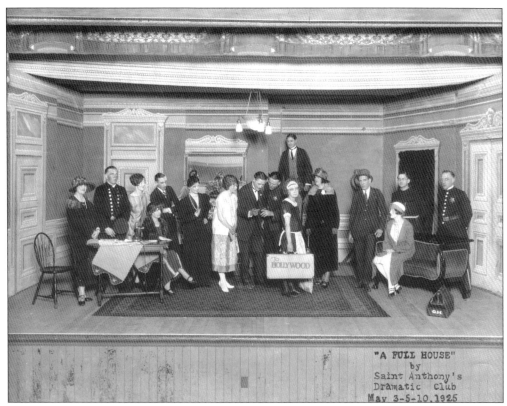

"A FULL HOUSE"
by
Saint Anthony's
Dramatic Club
May 3-5-10 1925

St. Anthony's Dramatic Club production of *A Full House* took place on March 5, 1925. August Willoh, fourth from left, was a local merchant. His family owned Willoh's Store at Twenty-fourth and Mission Streets. (Courtesy of St. Anthony-Immaculate Conception School.)

BID FOR FAME IN MUSICAL COMEDY

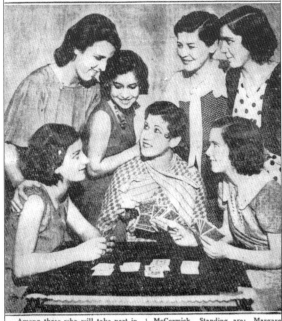

Students of the St. Charles Commercial School did not have to have acting classes but to perform in this musical comedy they had to have taken elocution. (Courtesy of Edna O'Brien Vierucci.)

Among those who will take part in musical comedy to be presented March 19 at San Carlos Hall by the St. Charles' Dramatic Club, are (sitting): Cecelia Mottershard, Edna O'Brien and Eileen McCormick. Standing are: Margaret Regli, Inez Montalvan, Katherine Stack and Aileen Garaboldi. Production mark thirty-fifth anniversary of the Rev. J. A. McAuliffe being ordained to priesthood

The new St. James School on Fair Oaks Street was designed by Alfred Coffey, Architects. The school has served the neighborhood since 1925. (Courtesy Archives for the Archdiocese of San Francisco.)

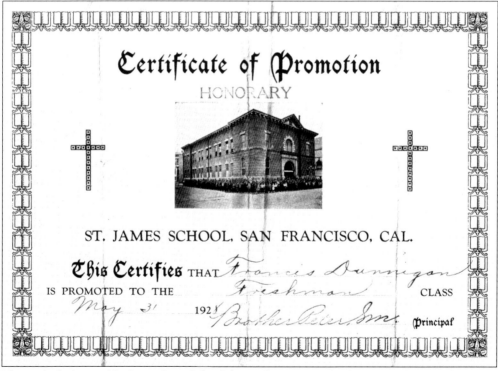

This early diploma of St. James Boys School, located at Twenty-third Street and Fair Oaks, shows how imposing it was. The boys' high school was closed in 1949, and the Brothers of Mary opened a new school, Riordan High, on Phelan Avenue. The original St. James Boys School is now rented to a private school. (Courtesy of Frank Dunnigan.)

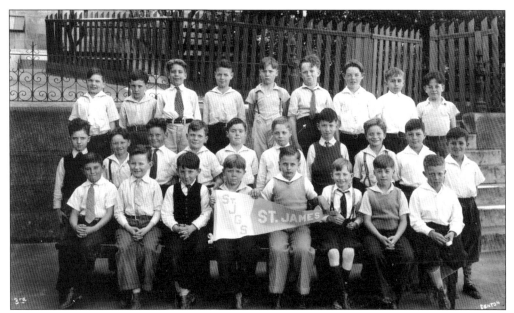

In 1935, third-graders Mickey Sweeney and Hans Meijer held a pennant proclaiming that they attended SJGS, St. James Girls School. For decades, younger boys attended school with the girls. Older boys went to St. James Boys School at Twenty-third Street and Fair Oaks. (Courtesy of private collection.)

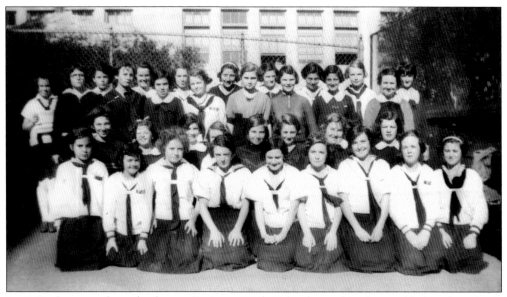

In 1937, the seventh-grade class at St. James Girls School posed in the yard below the school, normally used by school boarders. (Courtesy of Mary Evelyn Bisazza.)

School safety or traffic patrols were a popular activity for the civic-minded. Ted Scourkes, fourth from left, was a member of a school traffic squad in the 1930s. Ted graduated from Mission High and returned in 1969 as principal. In recent years, he founded the Mission High Alumni Museum. (Courtesy of Dr. Ted Scourkes.)

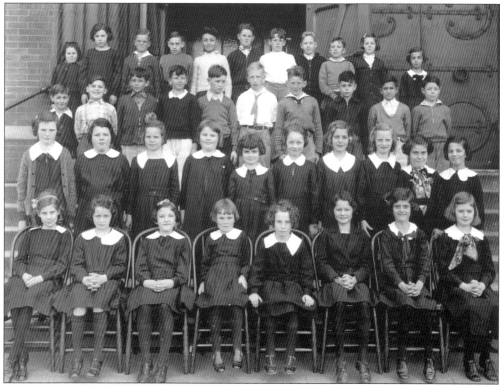

This photograph of St. Anthony School students from the 1930s (class of 1941) was taken in front of the doors to the original church. The church was destroyed in a 1975 fire. The elaborate doors were stolen soon after. (Courtesy of St. Anthony-Immaculate Conception School.)

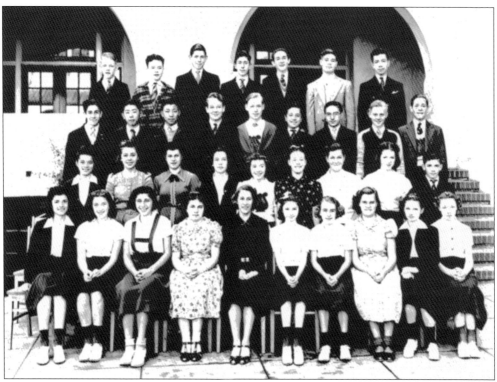

Everett is one of the three Mission District junior highs. Ms. Aronson, a young and much admired teacher, is pictured with her class in 1939. To the right of Ms. Aronson is Kate Fraden, a lifelong Mission District resident. Kate and her brother Jules grew up behind their father's Mission Street furniture store, and both graduated from UC Berkeley and taught at City College. (Courtesy of Kate Fraden Rosen.)

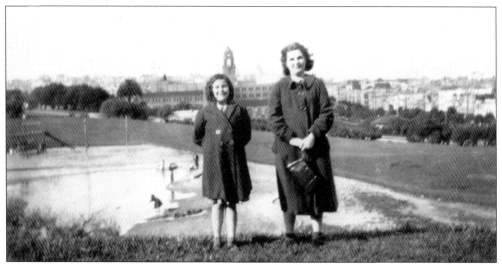

In 1939, a mother and daughter pose at Twentieth and Dolores Street with warm smiles despite the apparently cold day. To the left is a familiar sight to several generations of local children—a rainy-weather lake in the middle of their beloved playground. (Courtesy of San Francisco Public Library, SF002-132.)

UNITED STATES OF AMERICA
OFFICE OF PRICE ADMINISTRATION

373784 EK

WAR RATION BOOK No. 3

Void if altered

Identification of person to whom issued: PRINT IN FULL

NOT VALID WITHOUT STAMP

(First name) (Middle name) (Last name)

Street number or rural route _____

City or post office _____ State _____

AGE	SEX	WEIGHT Lbs.	HEIGHT Ft. In.	OCCUPATION

SIGNATURE _____
(Person to whom book is issued. If such person is unable to sign because of age or incapacity, another may sign in his behalf.)

WARNING

This book is the property of the United States Government. It is unlawful to sell it to any other person, or to use it or permit anyone else to use it, except to obtain rationed goods in accordance with regulations of the Office of Price Administration. Any person who finds a lost War Ration Book must return it to the War Price and Rationing Board which issued it. Persons who violate rationing regulations are subject to $10,000 fine or imprisonment, or both.

OPA Form No. R-130

LOCAL BOARD ACTION

Issued by _____

(Local board number) (Date)

Street address _____

City _____ State _____

(Signature of issuing officer)

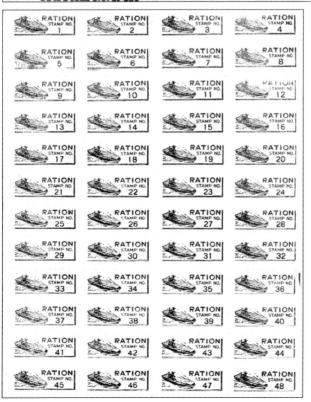

This ration book contains stamps with different images—ships, tanks, and planes—all meant to remind citizens of the result of their sacrifices. (Courtesy of private collection.)

Here is another page from the ration book.

Four

WAR AND CHANGE

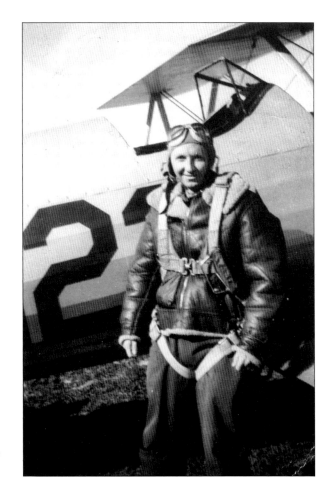

Robert Driscoll, a graduate of St. Anthony School and Sacred Heart High School, served in the Army Air Corps in Europe during World War II. He wrote home frequently. Like many men of his generation, he spoke little of his wartime experiences. (Courtesy of Marie Driscoll.)

John Hider went into the army during World War II, returned to the neighborhood he grew up in, and has remained there since. (Courtesy of John Hider.)

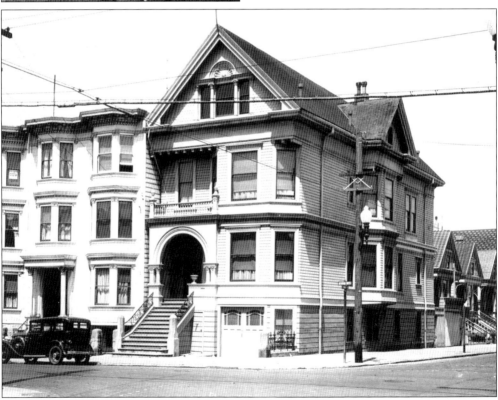

Located at Twenty-second and York Streets, this home was built for Charles Luhrmann, founder of the Old Milwaukee Brewery, later Burgermeister. In 1928, it was purchased by the Schier family. The garage was an early rarity. During World War II, blackout shades were mandatory. These had to be especially good. The local air-raid wardens met at this house. (Courtesy of Etienne Simon.)

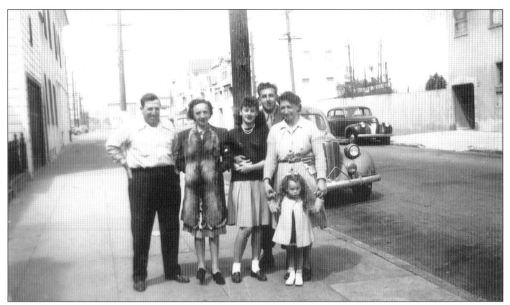

A neighborhood portrait on Hampshire Street dates to the mid-1940s. Pictured, from left to right, are Luigi Ungaretti, a native of Lucca, Italy; his sister-in-law Velma Zari; Dorothy Calvetti; Luigi's son, Lou, in military uniform; Elena Bianchi Ungaretti, Luigi's wife; and little Wilma Zari, Velma's daughter. (Courtesy of Lorri Ungaretti.)

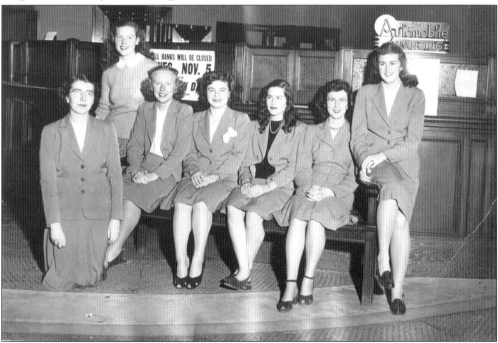

During World War II, the Hibernia Bank at Twenty-second and Valencia Streets employed many women who had recently graduated from high school. They were told that their jobs were temporary, "until the men come home." It did not work out that way, and women continued at their jobs. In 1944, Mary Thornton, Barbara Carrig, unidentified, Gloria Cavelli, Lillian Murphy, Roseanne Manning, and Nora Coffey posed for the bank photographer. (Courtesy of Ruane family.)

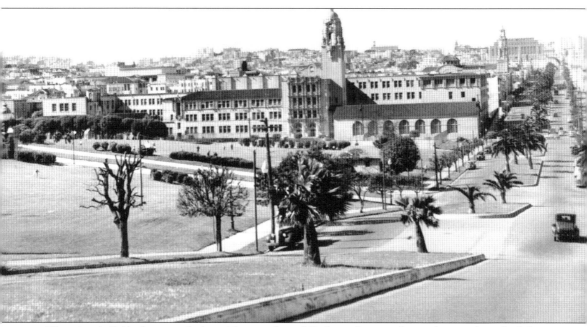

This April 1944 photograph from Twentieth and Dolores Streets shows the north end of the neighborhood towards Market Street. Mission High is prominent as is Dolores Park in the foreground. The palm tress, long a feature of the meridian, are now features of upper Market Street, near Castro and along the Embarcadero. There were fewer automobiles on the streets, partially because many people could not afford them and because gasoline was rationed during World War II. (Courtesy of San Francisco Public Library, SFPL AAA-6828.)

Dorothy Calvetti, now Dorothy Bryant, graduated from Mission High where she was a student body officer. As Dorothy Bryant, she has written fiction and nonfiction. One of her novels, *Miss Giambino*, is set in the Mission District. Dorothy's photograph is in the Alumni Room at Mission High. (Courtesy of Lorri Ungaretti.)

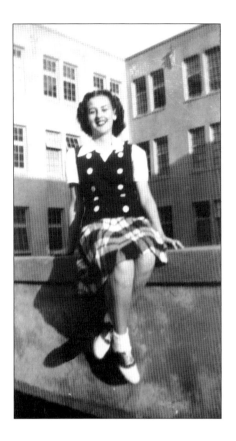

Mission High students pose for this photograph on the Eighteenth Street steps during the mid-1940s. (Courtesy of San Francisco Public Library, SF 002-118127.)

The new Immaculate Conception Academy (ICA) building, located on Twenty-fourth Street at Guerrero Street, was completed in 1928. The school has expanded in recent years but its original auditorium is still one of the best spaces in the neighborhood. (Courtesy of Immaculate Conception Academy.)

The ICA roof playground was a popular spot at lunchtime. Pictured here, from left to right, class of 1941 members (first row) Pate Needle and Helen Christian; (second row) Mary Evelyn Ruane, Pat Bird, and Pat Brown enjoyed the playground. (Courtesy of Mary Evelyn Bisazza.)

An Immaculate Conception Academy (ICA) graduate, Margie Manning, of Twenty-third Street, grew up to become a Dominican sister and taught at ICA. Known to her history students as Sr. Mary Edward, O.P., she was considered strict but fair. Here she watches intramural sports with Charlotte Sullivan, Theresa Dissi, and Barbara Schulz. (Courtesy of Anne Fuchslin.)

Members of the ICA class of 1943, Lorraine Maffei, Anne Fuchslin, Carmela Saitz, and Betty Barlow, shielded their eyes from the afternoon sun on the school roof. (Courtesy Anne Fuchslin.)

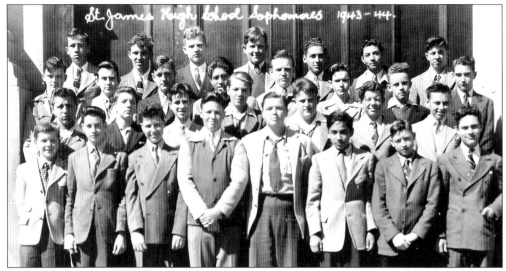

The St. James High sophomores of 1943–1944 stood on the steps of their school for this class photograph. Cornelius (Con) Murphy Jr., second row, fourth from the left, was chief of police from 1980 through 1985. Richard Weinand is in the third row, third from the left. Many classmates signed the back of the photograph, and they all had very good penmanship. (Courtesy of Richard Weinand.)

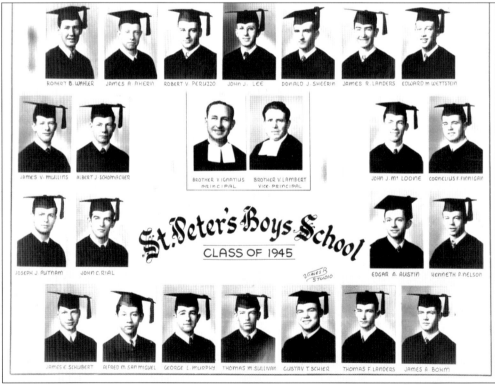

St Peter's High for Boys, at 1245 Alabama Street, was staffed by the Christian Brothers and had a reputation for high academic standards. This 1945 senior class photograph shows Gustav Schier, third from right, bottom row, a third-generation Mission resident. (Courtesy of Etienne Simon.)

In September 1945, Fred Fontana came back from the service to a warm reception by his Oakwood Street family and friends. Fred's family founded the Sunset Scavenger Company. (Courtesy of San Francisco Public Library, SF002-350.)

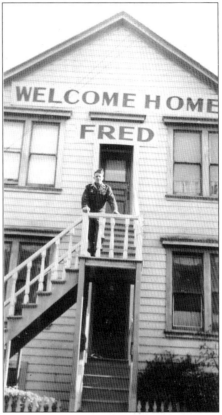

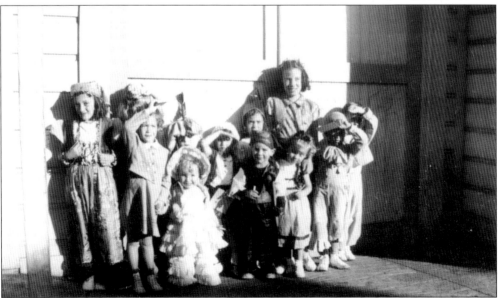

On Halloween 1945, Oakwood Street playmates gathered in the Campi's backyard. For many years, there was a Halloween night parade on Mission Street—no trick-or-treating, just a chance to greet neighbors. Most children's costumes were homemade, although Bo Peep's looks professional. (Courtesy of San Francisco Public Library, SF 002-366.)

Neighbors and friends turned out in big numbers at neighborhood weddings. Receptions were often small events. Members of the Donohue, Brannigan, and Murray families pause in front of St. James Church on Guerrero Street in 1947. During this time, a representative from the store that sold the wedding dress would be at the church to make sure the train was perfect when the bride went down the aisle. (Courtesy of private collection.)

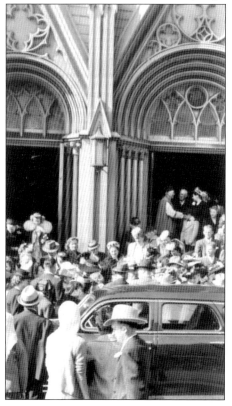

While Monsignor Quinn greets parishioners after Mass at St. James Church, other parishioners mill about on Guerrero Street. A block to the north, the Polly Ann Bakery had such brisk sales of coffee cake on Sunday mornings that it employed two cashiers. In a practice that continues to this day, churchgoers park along the meridian on Guerrero Street, narrowing Sunday traffic to two lanes. (Courtesy of private collection.)

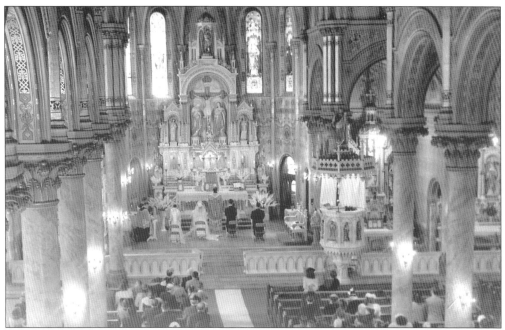

This is the interior of St. Anthony's Church on August 9, 1947, the day Katherine Westerhouse and Frank Dunnigan married. This couple met at Siegler's Resort in Lake County in 1936. Many young people who came of age during the Depression waited until "after the war" to marry. (Courtesy of Frank Dunnigan.)

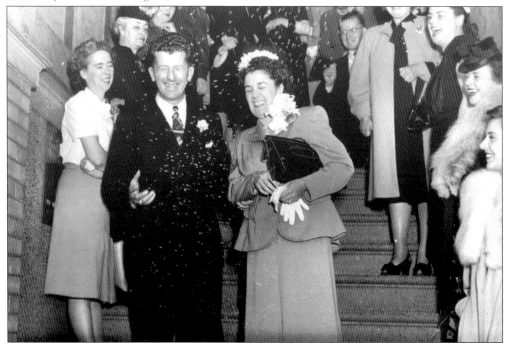

On their wedding day, Frank and Katherine Dunnigan leave her parents home at 836 Capp Street to the good wishes of friends and family. They raised their family in the Parkside but maintained strong Mission District ties. (Courtesy of Frank Dunnigan.)

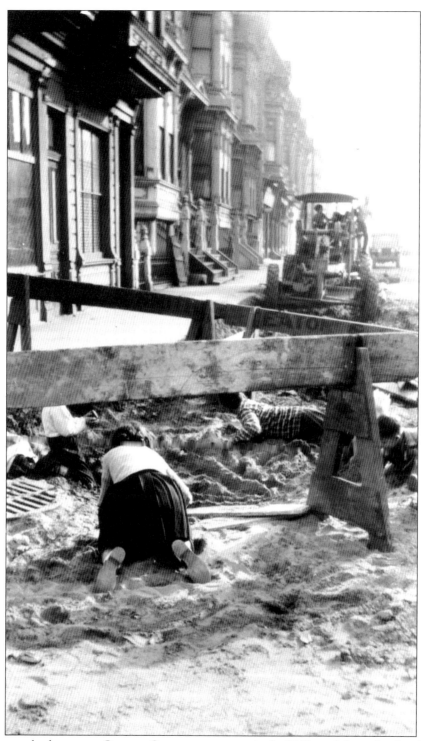

Streetcar tracks that ran on Guerrero Street were torn out in the 1940s, and the wide sidewalks were narrowed. The result was four lanes of traffic and a narrow meridian. Always a busy thoroughfare, automobile traffic increased. (Courtesy of private collection.)

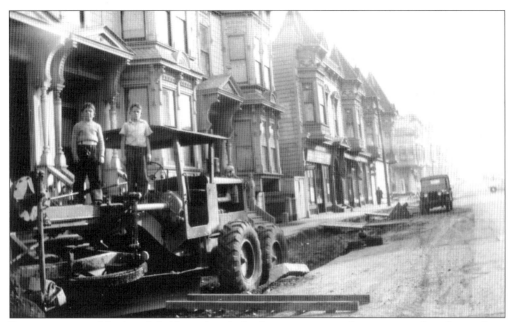

Ever curious, neighborhood children played after-hour inspectors of equipment when the roadway and sidewalks were altered on Guerrero Street. These photographs were taken by a young adult who probably identified with their activities. (Courtesy of private collection.)

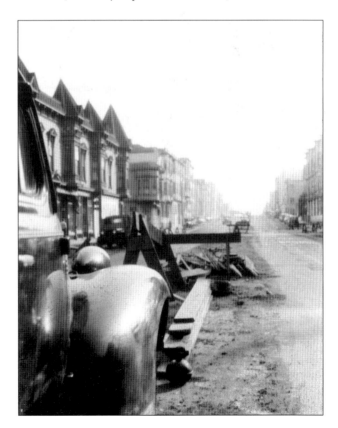

There have been few changes to the structures on this part of Guerrero Street, and this view to the south is much the same today. The biggest loss is the shingled Stewart Presbyterian Church and its community, now replaced by a plant nursery. Neighbors knew that the best bazaars were held there. Many who attended other places of worship considered themselves Presbyterians socially. (Courtesy of private collection.)

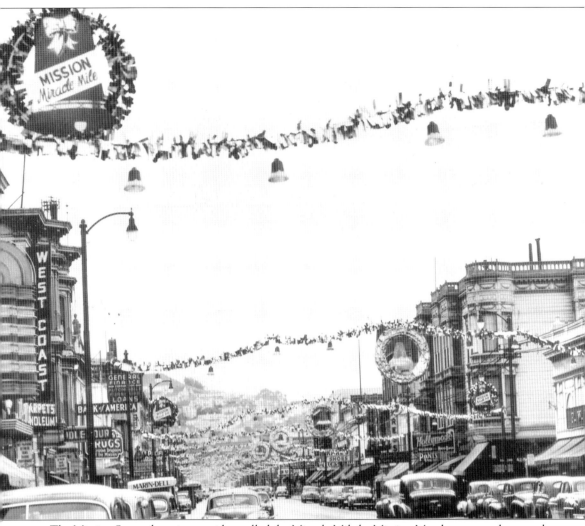

The Mission Street shopping corridor, called the Miracle Mile by Mission Merchants, was decorated with bells for the 1948 holiday season. Bells, usually called Mission bells, were a common theme in the neighborhood. Woolworth's was an anchor at Twenty-third Street for decades as was Willoh's store at Twenty-fourth Street. There were three movie theatres within a block, enough to satisfy the biggest matinee fan. The New Mission was the grandest. (Courtesy of San Francisco Public Library, AAB-4704.)

Fred Baciocco, Antonio Baciocco's son, operated his Star Sheet Metal and Heating Company on Twenty-fourth Street next to the building that had been his father's Progress Fruit Market. In 1948, the new company truck was parked in front of the business. (Courtesy of Baciocco family.)

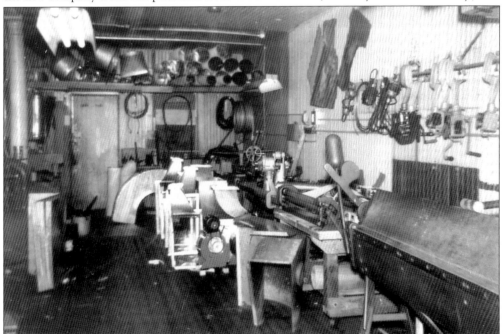

The interior of the Star Sheet Metal and Heating Company shows Fred Baciocco's tools of the trade. Many items were fabricated onsite. The ability to run a successful business while making complicated items to specifications could be a family trait. Albert's sister Elizabeth, later Elizabeth Mullan, trained at Cogswell College to be a milliner. She owned Ellabeth, a dress shop and millinery on Mission Street near Ocean Avenue, from the 1930s to the 1960s. (Courtesy of Baciocco family.)

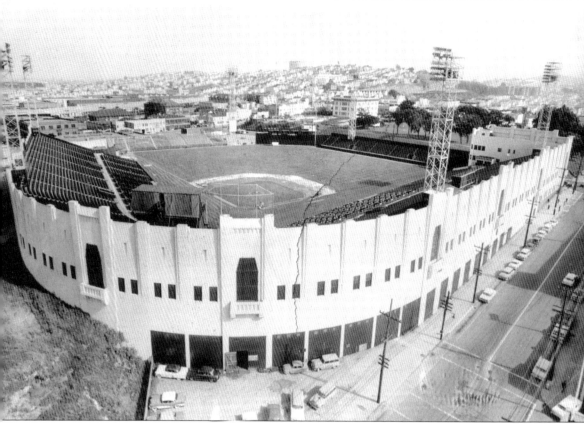

Seals Stadium at Sixteenth and Bryant was the fourth home of the San Francisco Seals of the Pacific Coast League. They started out at Recreation Park at Eighth and Harrison in 1903. It burnt down in the days following the 1906 earthquake. Their next home, located at Fifteenth and Valencia Streets, was also called Recreation Park. They played there from 1907 until 1930. For half a season in 1914, they attempted to play in foggy Richmond at Ewing Field near Masonic Avenue. Players and spectators could not see the balls, so they moved back to the sunny Mission and stayed. Their final home, Seals Stadium, was built in 1930. In 1957, the Seals made way for San Francisco's first major league team, the Giants. After two seasons, the Giants vacated Seals Stadium. It was torn down in November 1959. (Courtesy of Martin Jacobs.)

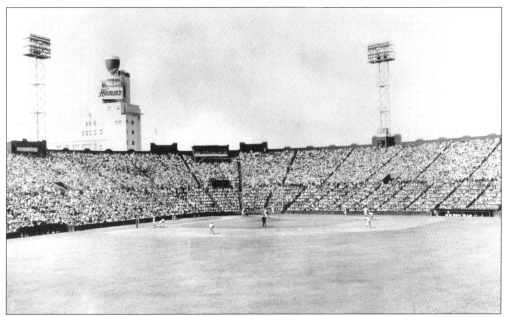

Many major league players got their start at Seals Stadium. Joe, Dom, and Vince DiMaggio all played at Seals Stadium. The Seals' biggest rival was the Oakland Oaks, who played in Emeryville. The team was financially successful because games were well attended. One remarkable feature of the skyline, seen from the Central Skyway and from Seals Stadium, was the foaming Hamm's brewery sign. (Courtesy of Martin Jacobs.)

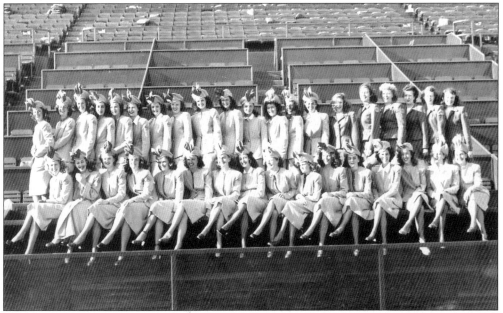

These young ladies presented a very polished image for Seals Stadium. The city had come a long way from the chicken-wire fences of Recreation Park. Clean and neat, the new stadium was a treat on a nice day, of which there are many in the Mission. When it was torn down, it took San Francisco 30 years to produce another ballpark with similar weather and convenience. (Courtesy of Martin Jacobs.)

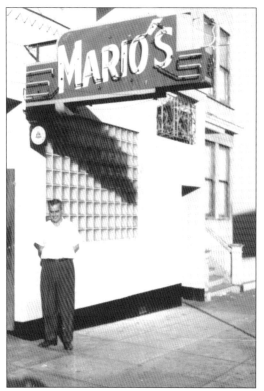

Mario Bisazza grew up on Bartlett Street near Twenty-second with his sister Tillie and his brother Guido. From the 1950s to the early 1960s, he owned Mario's bar on Twenty-second Street. Before sports bars became popular, groups of his patrons would go to ball games together. He also liked to cater to special requests and started serving wine when one patron said she preferred it to beer and hard liquor. (Courtesy of Kathleen Regan.)

When Bill O'Rourke, third row, far left, came back from the Korean War, he worked at the Golden State Dairy on Guerrero Street near Sixteenth Street. San Francisco was a union town, and Bill belonged to Local 226, milk wagon drivers. He went on to be the business agent for Local 921 of the newspaper drivers. (Courtesy of Florenceann O'Rourke.)

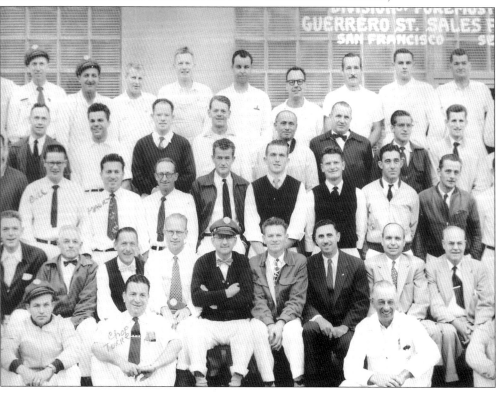

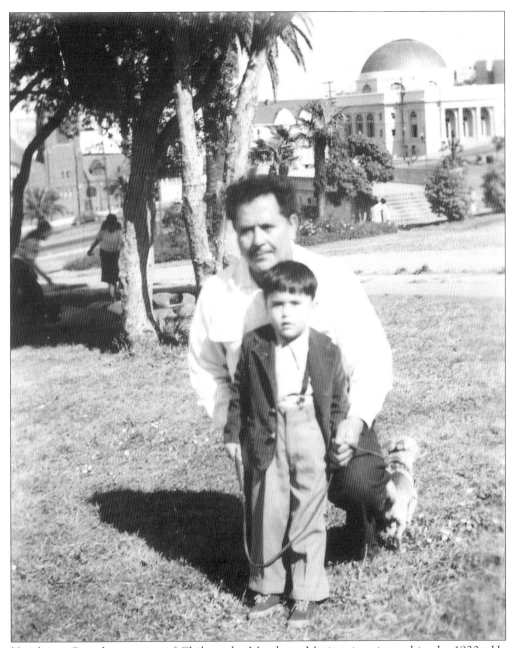

Humberto Cepeda, a native of Chile and a Merchant Marine, immigrated in the 1920s. He married Florence Moorehouse, a navy nurse from Pennsylvania. They lived in the Mission with their children, Joe, Betty, and Florence. Here Humberto Cepeda is with his son Joe and the family dog, Gaucho, in Dolores Park in the early 1950s. A well-rounded personality, Humberto enjoyed classical music and gave a daughter opera glasses when she was five. (Courtesy of Florence Cepeda.)

Lupe Abeyta and her daughters Mary Ann and Linda enjoyed the afternoon sun at Dolores Park, c. 1949. Lupe and her husband, Ralph, both grew up in New Mexico. Friends introduced them at a San Francisco dance. Later they figured out that they had already spent a lot of time near each other. Ralph had recently been Lupe's upstairs neighbor. Late at night, Lupe would hear him returning home from school or his shipyard job. One shoe would hit the floor. Fifteen minutes later, she would wake up again when the second shoe hit the floor. (Courtesy of Ralph and Lupe Abeyta.)

In 1952, an Edison School kindergartner stands in front of McKannay's Drug Store, located at Twenty-second and Guerrero Street, for her five-year birthday picture. The tracks for the streetcar that ran on Twenty-second Street are still in use, the Pride Superette is one of the largest grocery stores in the neighborhood. (Courtesy of Ruane family.)

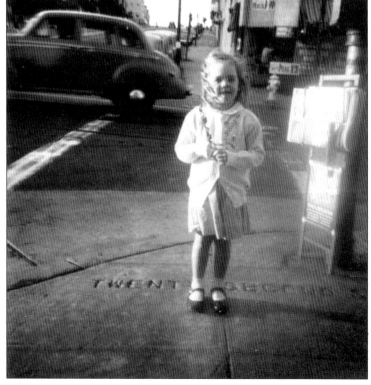

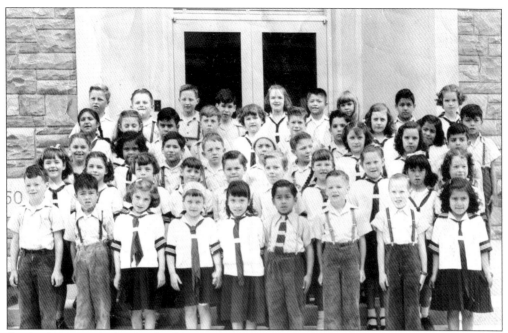

St. Anthony's 1950 first-grade class poses on the steps of their new school on Precita Avenue. The old school was moved to face Shotwell Street and still functions as the parish hall. The boys wore salt and pepper tweederoy slacks, and the detachable collars and cuffs of the girls' middy blouses were wool. (Courtesy of Marie Driscoll.)

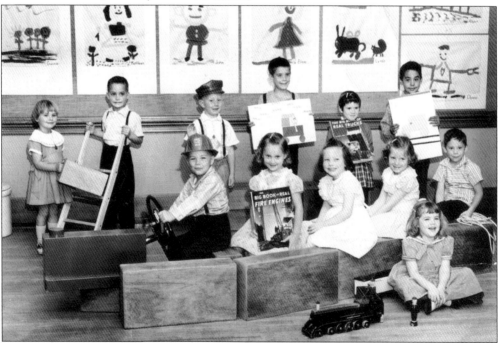

Dorothy Vaio taught in San Francisco public schools for decades. Her Edison School kindergarten class in 1955 included at least one future policeman, a physician, and a soccer mom. (Courtesy of private collection.)

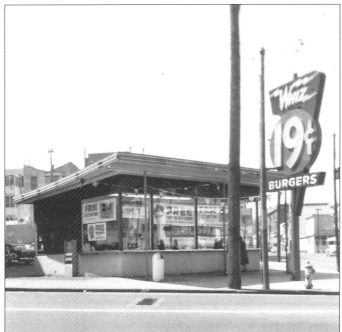

John Hider opened Whizz Burger on March 23, 1955, at Eighteenth and South Van Ness. A neighborhood resident, John learned early what patrons wanted from the days when he helped out at his mother's Handy Stop Market. (Courtesy of John Hider.)

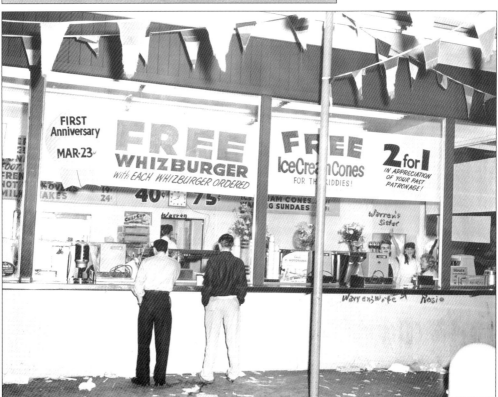

The very modern look of Whizz Burger stands out in this neighborhood with its many older buildings. Popularity required many employees. During large volume times, the ice cream supplier sent additional staff. (Courtesy of John Hider.)

A year after opening, Whizz Burger celebrated with a gift to the neighborhood—free ice cream. Schoolchildren joined the line for their treats. (Courtesy of John Hider.)

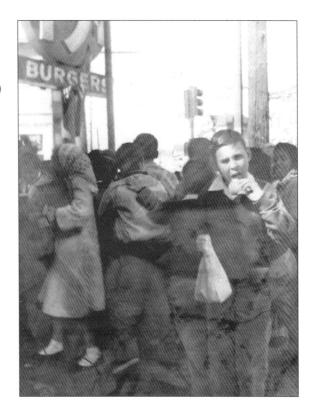

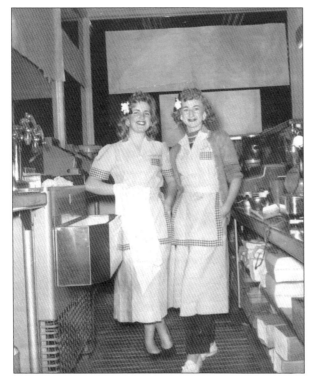

The neighborhood has gone through many changes in the last 50 years, but Whizz Burger has maintained its character and appearance. (Courtesy of John Hider.)

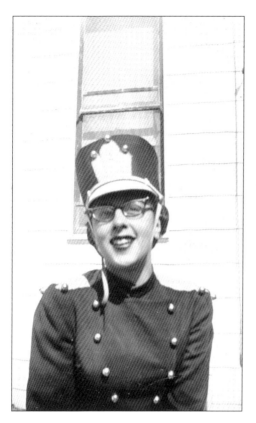

Theadora "Teddy" Vasquez moved to the Mission from North Beach as a child. At Horace Mann Junior High she was the first trombonist in junior high band. Along with Margaret Connolly, she joined the Mission Boys Club (before it became the Boys and Girls Club) and played in their band since there were not enough boys to fill the brass section. Teddy was valedictorian at Horace Mann and salutatorian at Mission High. At the age of 20, she joined the United States Air Force where she earned the outstanding WAF award. (Courtesy of the Vasquez family.)

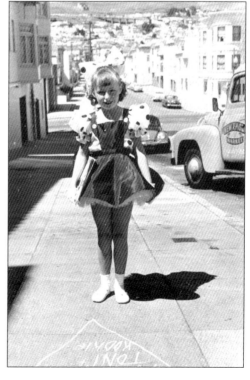

Katherine Bellis stands in front of her family home at 77 Jersey Street. She is on her way to the annual May Day celebration at Golden Gate Park. Children from dancing schools trained for months for the event. Katherine was a student of the Betty May Dance Studio on Guerrero Street. Betty May taught ballet, tap, and ballroom dancing for decades. In the background is a delivery truck for the New Eagle Market, owned by the Muzio family. At Katherine's feet is a chalk testimonial to Edd Byrnes, also known as Kookie, of the popular show *77 Sunset Strip*. (Courtesy of Katherine Bellis Hamburger.)

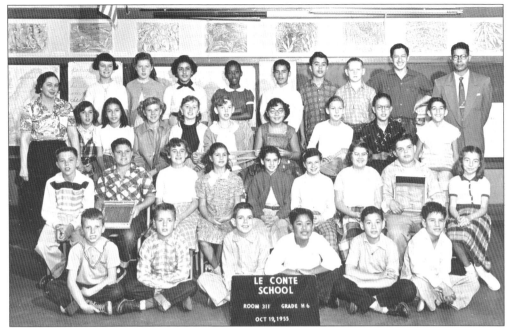

Manuel Vasquez, back row, second from right, lived at several locations in the Mission, went to neighborhood schools, and to San Francisco State. He taught at public schools in the city. He is pictured here with his sixth-grade class at Le Conte School (now Leonard Flynn) in 1955. (Courtesy of Vasquez family.)

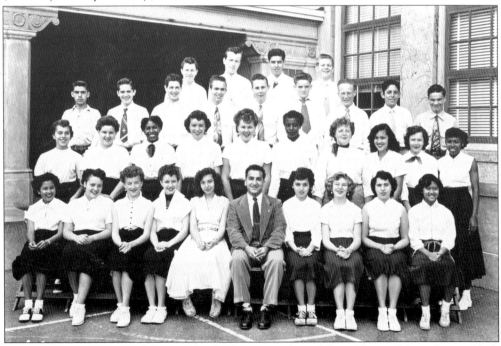

Augustin Vasquez, second from right, back row, graduated from Horace Mann Junior High in 1954 and went on to become accountant and career employee at Chevron. (Courtesy of Vasquez family.)

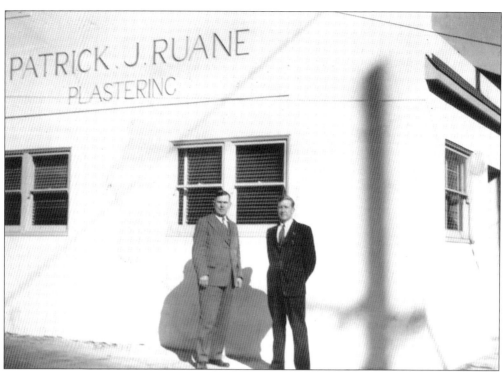

Patrick J. Ruane and his company estimator, Harry Southward, stand in front of Patrick's plastering company at San Jose Avenue and Alvarado, c. 1950. Patrick's company had large plastering contracts, including Park Merced. He was proudest of his work as the foreman plasterer of the pump house at Hoover Dam. Two of his brothers, Martin and Malachy, were also plasterers. Malachy's son Jim now owns the company. Its restoration work at the Palace Hotel was honored with an award from the National Trust for Historical Preservation. (Courtesy of Ruane family.)

Canned goods shook off the shelves at Lilly Hider's Handy Stop Market at Eighteenth and South Van Ness on March 22, 1957, the day of an earthquake measuring 5.3 on the Richter scale. This photograph may have been taken for insurance purposes or to commemorate the messy cleanup that was to follow. (Courtesy of John Hider.)

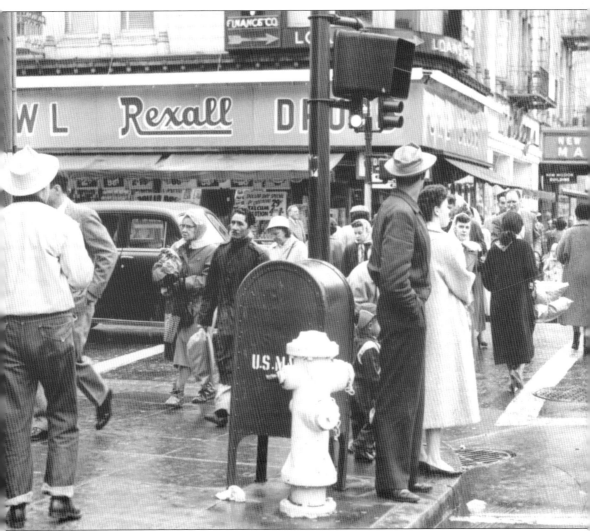

Dollar Days were very popular on Mission Street, as this 1959 photograph of Twenty-second and Mission Streets shows. Shoppers crowded over 400 district stores to take advantage of bargains during the twice-yearly sale. Locals referred to shopping on that street as "going down Mission." If one was in a hurry to get home or get downtown fast, they could take a jitney, a type of taxi/van that picked up passengers along Mission Street. (Courtesy of San Francisco Public Library, AAB-4721.)

Until 1959, the Dominican Sisters cared for the young boarders of St. James Girls School and Immaculate Conception Academy. Linda Bishop, left, and another boarder pose on the steps to the school in this 1958 photograph. (Courtesy of private collection.)

St. James boarders had a special playground behind the convent at 1212 Guerrero Street that was normally off limits to the school. In this photograph, boarders mingle with several day students. The merry-go-round was particularly wobbly and required more skill than the ones at local playgrounds. It was not approached by the timid. (Courtesy of private collection.)

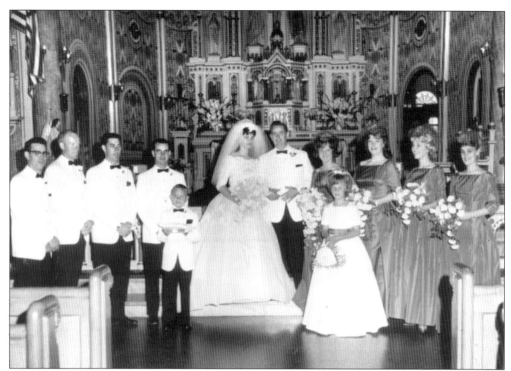

Family life in the Mission included many celebrations. Dana Driscoll and Jim Hickey married on August 24, 1963, at St. Anthony Church. Their wedding reception was held at Roberts-at-the-Beach, and their band was the Irish Pipers. (Courtesy of Marie Driscoll.)

A young boy helped hang out the wash on Folsom Street in 1961. Clothing lines were very common, as not everyone had a dryer. The key to success was properly securing the pin to the clothing and the line. An inexperienced pinner could end up making unscheduled visits to neighbor's yards to retrieve flown-away items. (Courtesy of San Francisco Public Library, SF 002-129.)

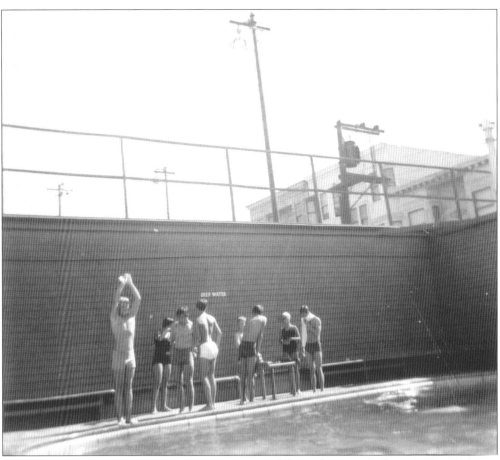

These photographs from 1962 include members of the Seals, the Mission Pool swim team. Their coach, Mark Graham, was employed at the pool from the 1930s and also served as lifeguard. Many Seals continued their sport competitively into high school and beyond. In the 1970s, one former Seal team member, a female, swam the length of the Golden Gate Bridge. Her time was better than most of the men who swam "The Gate" that day. (Courtesy of private collection.)

When the pool was closed, Mark, the coach, would allow his Siamese cats, Sissy and Bum, to have the run of the place. Memories differ about the felines' experience with water. Some recall seeing them swim, while others maintain that Mark scooted them around the shallow end on boogie boards. (Courtesy of private collection.)

The Mission Pool on Nineteenth Street (between Valencia and Guerrero Streets) has been a neighborhood institution since 1916. It is called Nickel Pool by locals because for many years, bathing suit, towel, and locker rental cost 5¢. At 30 yards long and 10 yards wide, it is smaller than the newer pools, but it has the distinction of being the only outdoor public pool in the city. Nickel Pool has survived many changes and retains its simple charm. (Courtesy of private collection.)

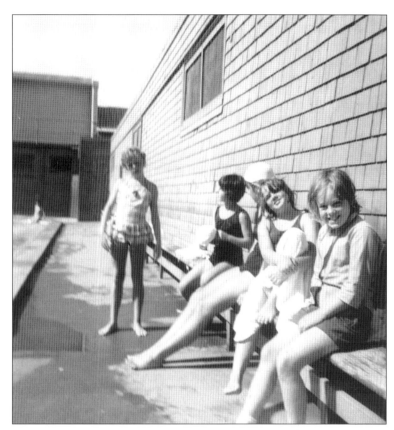

Many neighborhood children have had their first swimming experience at Nickel Pool. In the 1930s, students at Horace Mann Junior High were required to know how to swim, and their ability was tested at Nickel Pool, four blocks from their school. (Courtesy of private collection.)

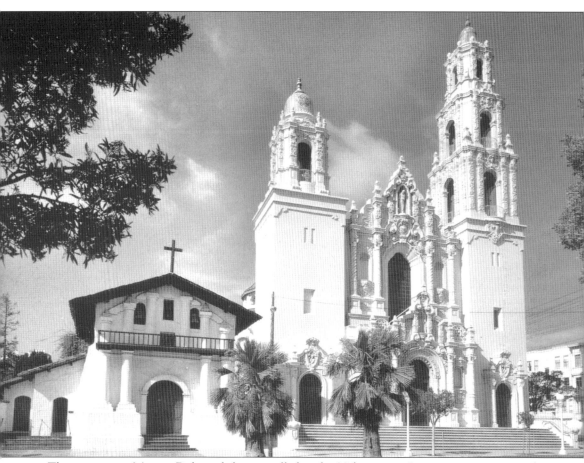

The cemetery at Mission Dolores, left, was walled in the 20th century. Its monuments are a study in early settler names but by no means are they all Spanish or Irish. The gold rush attracted settlers from several continents. Thousands of Ohlone are buried on the grounds and nearby, as the Mission property was once more extensive. (Courtesy of Archives of the Archdiocese of San Francisco.)

For many years, on the anniversary of the founding of San Francisco, the army at the Presidio, and the Mission Dolores community came together to celebrate their joint history. On June 29, 1963, the day's activities included a luncheon at the Presidio and a service at Mission Dolores. In the Mission cemetery, a representative of the army, a Franciscan friar, a descendant of the early settlers, and Bishop Guilfoyle, a Mission native, gathered for a photograph. The descendant, called "La Favorita," for the day was Patricia Oliver Vallejo McGettigan. Patricia was a great-great-granddaughter of Mariano Vallejo, governor during the Mexican period. (Courtesy of Molly McGettigan Arthur.)

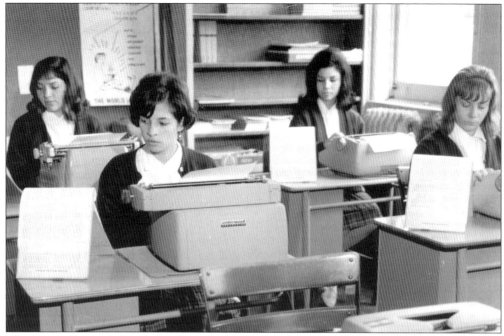

The typing class at St. Peter's Academy in 1964 included Mary Ann Abeyta, back row, right. Note the "Help Wanted, Valiant Women" poster, inferring that valiant women can type. (Courtesy of Ralph and Lupe Abeyta.)

St. Peter's Academy closed in June 1966. In this photograph, the class leaves St. Peter's Church after their graduation exercises. Pictured, from left to right, are Linda Abeyta, Sr. Mary Aloysius, and Sr. Mary Jude. (Courtesy of Ralph and Lupe Abeyta.)

In 1965, the Mission Dolores School traffic boys head out onto Sixteenth Street to make the crossings safe for their schoolmates and neighbors before and after school and at lunchtime. (Courtesy Archives for the Archdiocese of San Francisco.)

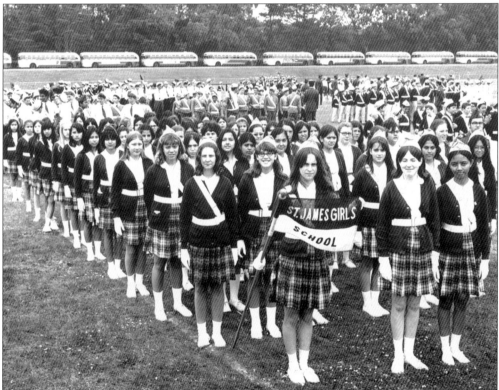

The St. James Girls School traffic patrol of 1968 participated in the yearly all-city, traffic-patrol event at the Polo Fields in Golden Gate Park. The school had the distinction of being the only all-girl traffic patrol in San Francisco. (Courtesy of St. James School.)

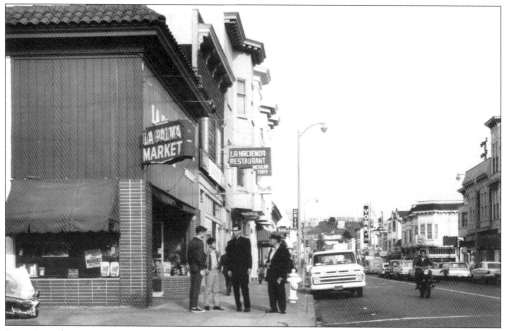

In 1964, John Petroni of St. Peter's Church stopped on Twenty-fourth Street to speak with other locals. The scene has a stark appearance because many trees line the streets now. (Courtesy of Archives for the Archdiocese of San Francisco.)

Fr. Victor Bazzanella, OFM, was the longtime pastor of the Immaculate Conception Church on Folsom Street Hill. He opened the parish school in 1957. Immaculate Conception Church was founded as the Italian National Church for the Archdiocese. It is now a chapel of St. Anthony's parish. (Courtesy of St. Anthony-Immaculate Conception School.)

Dolores Park has become a place to march to and from for rallies and various causes. This event, in support of the United Farm Workers (UFW), was held in 1968. (Courtesy Archives for the Archdiocese of San Francisco.)

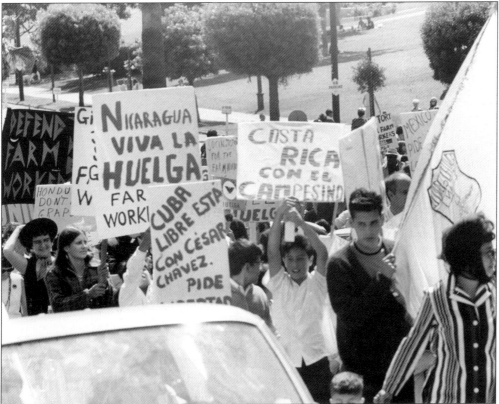

In 1968, various related causes were represented during a march from Dolores Park. Mission residents, like many San Franciscans, appreciate the desire to march whether or not they march themselves. (Courtesy Archives for the Archdiocese of San Francisco.)

Cesar Chavez, president of the United Farm Workers (UFW), is pictured here with neighborhood resident and one-time UFW organizer, Roberto Hernandez. People who had never seen the fields of the Central Valley or produce except at the market were inspired to join boycotts by Chavez's leadership. Army Street (once called New Market) has been named Cesar Chavez Boulevard in his honor. (Courtesy of Roberto Hernandez.)

Five

RECENT YEARS

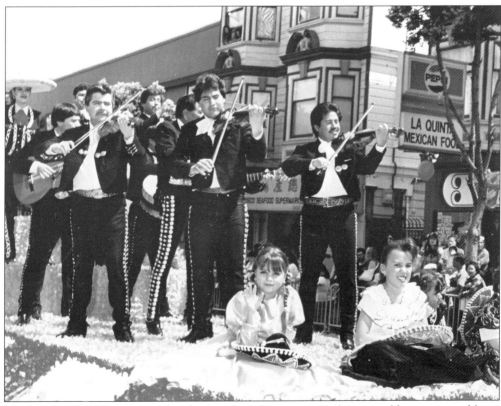

Neighborhood celebrations and gatherings have become more diverse and have attracted large crowds in recent years. One of the biggest is Cinco de Mayo, commemorating the victory of Mexican forces over the French at the Battle of Pueblo. (Courtesy of Roberto Hernandez.)

One of the most distinctive features of the Mission District are the murals on businesses, schools, and fences. The mural at La Palma Market on Twenty-fourth Street and Bryant is an example of local artistry. The biggest draw is Balmy Alley, off Twenty-fourth Street, where murals depict politics, cartoon figures, and even the No. 14 Mission bus. (Courtesy of author.)

Twenty Fourth Street has had many long-standing businesses. The St. Francis Fountain has been at the corner of Twenty-fourth Street and York since 1918. The 1926 movie house, once called the Roosevelt (or the Roosie to locals) and later the York, was purchased in 1996. Renovated and dedicated to the presentation of works by women, the Brava Theatre Center's other goal is to serve as a neighborhood center. Theater Artaud and the ODC Theater, both influential, are also located in the Mission. (Courtesy of author.)

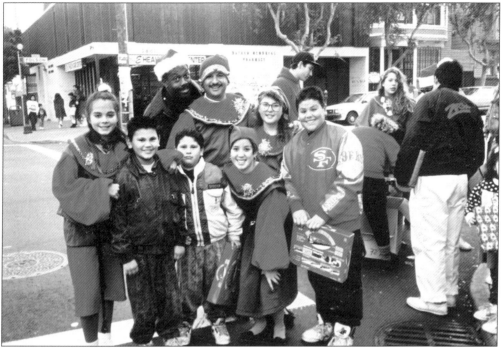

A Christmas parade and toy giveaway was a yearly sight along Twenty-fourth Street from 1990 to 1995. One year, 1,000 toys were distributed. (Courtesy of Roberto Hernandez.)

Precita Park is appreciated by all neighbors; however, children may enjoy it most as a break from the confines of the schoolyard. (Courtesy of St. Anthony-Immaculate Conception School.)

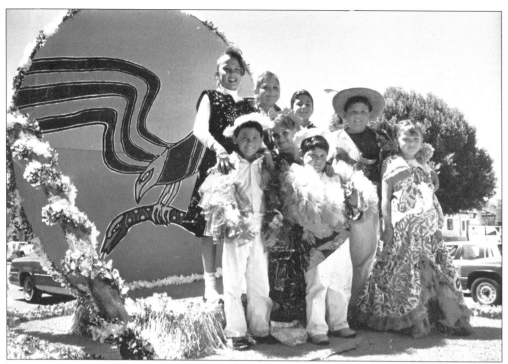

In 1979, Carnaval San Francisco was started as a small event with the intention to march a few times around Precita Park. Instead the parade kept going around the park all day. A young man assigned to security assessed the relaxation level of the crowd and went home to get his drums. Over the years, the participants and the viewers have ranged in age. (Courtesy of Roberto Hernandez, Carnaval San Francisco.)

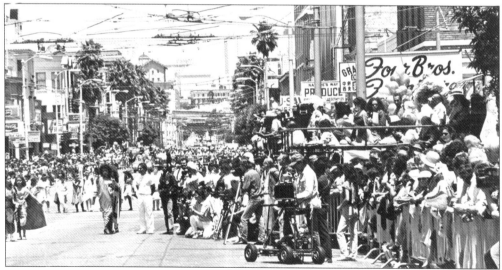

Mission Street is lined with crowds for viewing Carnaval. The parade route is typically Twenty-fourth Street and Bryant to Mission Street and Mission Street to Seventeenth Street, where it concludes in a festival. Although it started out small, it is now the largest multicultural event in California, focusing on Latin American and Caribbean cultures. (Courtesy of Roberto Hernandez, Carnaval San Francisco.)

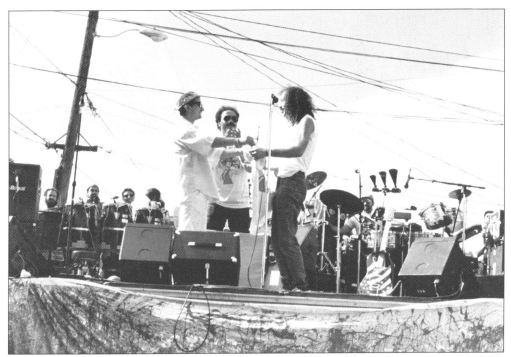

Getting back to his Mission roots, Carlos Santana appeared on stage during the early 1980s. The stage was then at Harrison between Twenty-third and Twenty-fourth Streets. (Courtesy of Roberto Hernandez, Carnaval San Francisco.)

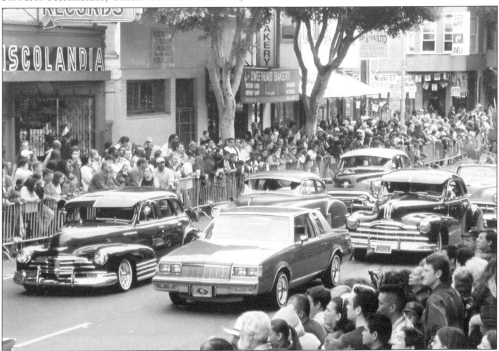

The crowds on Twenty-fourth Street were the first to see this parade of low riders. (Courtesy of Roberto Hernandez, Carnaval San Francisco.)

The restaurants and bookstores of Valencia Street, between Sixteenth and Twenty-third Streets, attract many locals from inside and outside of the neighborhood. For over 75 years, Lucca's Ravioli Company at Twenty-second and Valencia Streets has had a loyal following for those who want to eat fine pastas at home. Jessen's, a bicycle shop, was in the building that now serves as Lucca's parking lot. (Courtesy of author.)

Across the street from Lucca's, the former Hibernia Bank has altered its purpose but not its classic appearance. Many San Franciscans had their first experience with saving money by using Hibernia Bank's signature soup-can size penny banks. (Courtesy of author.)

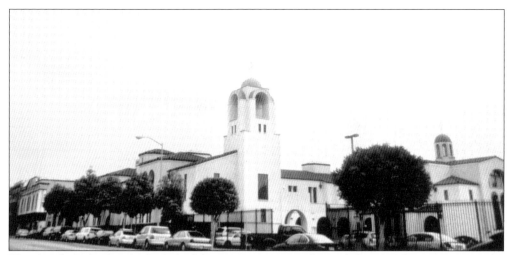

The Greek Orthodox Cathedral of the Annunciation is located at 245 Valencia Street at the site of Woodward Garden's pavilion and the Valencia Theatre. The alley behind the cathedral is called Woodward. The first cathedral was the former Valencia Street Theater. Damage from the Loma Prieta earthquake of 1989 forced the Greek community to rebuild. (Courtesy of author.)

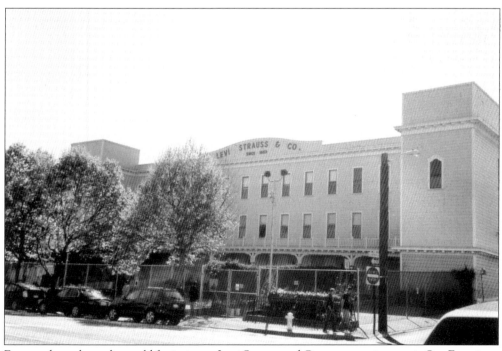

Famous throughout the world for its jeans, Levi Strauss and Company got its start in San Francisco. A company factory was located on Valencia Street. Into the 1960s, the company donated scrap fabric to neighborhood schools' rag drive fund-raisers. These events were popular long before the word recycling was used. (Courtesy of author.)

Many former industrial buildings in the Mission have been converted to housing. Now condominiums, this building on York Street was a mill for over 100 years. (Courtesy of author.)

Across York Street from the former mill are small Victorian homes, a carefully preserved part of local heritage.

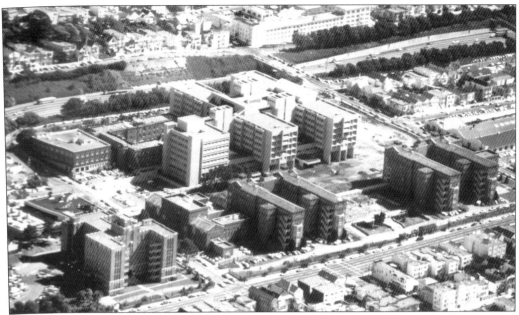

San Francisco General Hospital (SFGH) has moved from small county hospital on the edge of the city to a facility that serves diverse populations. The emergency/trauma care is the best in the region. When the AIDS epidemic began, SFGH was on the front line in care. (Courtesy of San Francisco General Hospital.)

This view to the northeast of downtown, and beyond shows how much the city has grown from the tiny Mission Dolores, lower right, a settlement near a lagoon. (Courtesy of Archives for the Archdiocese of San Francisco.)

ACROSS AMERICA, PEOPLE ARE DISCOVERING SOMETHING WONDERFUL. *THEIR HERITAGE.*

Arcadia Publishing is the leading local history publisher in the United States. With more than 3,000 titles in print and hundreds of new titles released every year, Arcadia has extensive specialized experience chronicling the history of communities and celebrating America's hidden stories, bringing to life the people, places, and events from the past. To discover the history of other communities across the nation, please visit:

www.arcadiapublishing.com

Customized search tools allow you to find regional history books about the town where you grew up, the cities where your friends and family live, the town where your parents met, or even that retirement spot you've been dreaming about.